PHOTOGRAPHER'S
Questions & Answers

Michael Busselle is well known as the author of thirteen books, including **England - The Four Seasons, The Art of Photographic Lighting** and **Discovering the Country Vineyards of France**, and has also been a regular contributor of articles and photographs to magazines. A professional photographer for more than thirty-five years, he works from his own studio in Kent and specializes in travel and landscape photography.

PHOTOGRAPHER'S
Questions & Answers

MICHAEL BUSSELLE

HarperCollins*Publishers*

First published in 1983 by
William Collins Sons & Co Ltd

Revised 1987, 1994

Reprinted 1988, 1989, 1991, 1994

Copyright © 1983 Nicholas Enterprises Ltd.

**A catalogue record for this book is
available from the British Library**

ISBN 0 00 412727 7

Editorial Director
Clare Howell

Editor
Hilary Dickinson

Art Editor
Christopher White

Designer
Martin Atcherley

Illustrations
Rick Blakely

Phototypeset by Dorchester Typesetting Group Ltd, Dorchester
Illustrations originated by East Anglian Engraving Ltd, Norwich
Printed in Belgium

Contents

Introduction

The great improvements in design and technology which have been made in both cameras and materials over the last decade now mean that it is possible for someone with no knowledge or experience of photography to take quite acceptable pictures with the minimum of effort and thought. Indeed, many people do not feel the need to delve into what may appear to be the complexities of photography; yet the knowledge required to take good photographs and to understand how cameras work and how they can be used to the best effect is in fact far from complex.

One of the most simple and direct ways of learning any skill is by asking questions of someone who is more experienced. In this way you can assimilate the knowledge as and when you need it, and you can learn at your own pace and with a particular emphasis to suit your needs at a given time. *Photographer's Questions and Answers* has been designed for this specific purpose. The questions have been drawn from a wide variety of people of different experience and interest, from professional photographers to new enthusiasts, and they have been selected according to the frequency with which they occurred. While it would obviously not be possible to anticipate every single question that a photographer might ask, the criteria on which the selection is based should ensure that the majority of problems that will be encountered, and difficulties in understanding both theoretical and technical matters, will be solved easily and clearly on these pages.

In order to make it both quick and easy to find the answer to a question, the book has been divided into a number of different sections, each dealing with a number of specific topics. The questions themselves are designed in a clear and easy-to-use form so that the appropriate answer can be located at a glance. The subjects covered in the book range from cameras, lenses, film, accessories and lighting, to camera technique, style and approach, darkroom techniques, and special problems and practical information. All aspects of the subject are dealt with, and there is also a fund of suggestions for new creative approaches.

The questions have been graded into three categories, for beginner, intermediate, and advanced, each easily identifiable with symbols, so that you can select the most suitable level of information to match your needs, skill, and experience. It is intended essentially to be a reference book, that will not only clarify points that have arisen from actual experience or from reading other books, but will also introduce new thoughts and ideas. More than this, it is intended as a dialogue set out in a lively question-and-answer form which will both stimulate and inform.

The technology of photography continues to advance in leaps and bounds. Today's cameras are far more sophisticated than even those made just a few years ago. For example, autofocus is standard now on 35mm equipment but manual focus is still the norm for roll film and larger format cameras. Film goes on changing, too; the newest films are faster and sharper, and have brighter colours and less grain.

You will find many questions that are especially relevant to the latest cameras, lenses and films.

Key to symbols

■ beginner

■■ intermediate

■■■ advanced

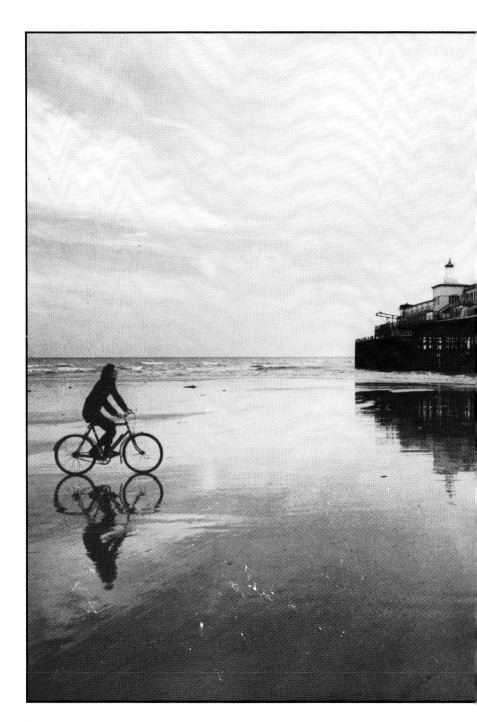

Cameras

How cameras work

■
Why do some cameras not have a focusing control?

Either because the camera focuses by itself, or because the lens is focused permanently at about 10 to 13 feet (3 to 4 metres), and objects closer or further than this appear acceptably, but not critically, sharp.

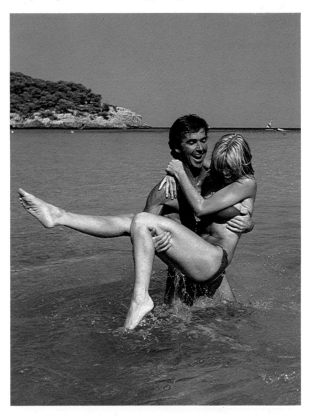

This informal holiday shot is a suitable type of subject for a fixed focus lens.

■
Why is it that everything looks quite sharp in the viewfinder of my camera no matter where it is focused?

This is because a viewfinder camera uses a separate optical device which projects a different type of image purely for the convenience of viewfinding. A camera with a focusing screen such as an SLR or a twin lens reflex will show a distinction between sharp and unsharp planes.

■■
Are modern cameras focused in a different way from early cameras?

The principle of focusing is that the lens is moved further away from the film as the subject comes closer to the camera in order to focus a sharp image. With a 35 mm camera, for example, this is achieved by means of a helical thread which extends the lens as the mount is rotated.

■■
What is a camera obscura?

This was the forerunner of the modern camera and dates from the sixteenth century. It was simply a darkened room in which an image of the scene outside was projected on to a wall by means of a lens or a small hole. Later versions were portable which allowed the user to set it up like an ordinary camera and trace the image on to paper.

■■
How did the ordinary camera develop from the camera obscura?

As a result of the discovery of light-sensitive chemicals which could be coated on a plate and would record the image projected on to it.

■■
How does the early plate camera differ from the modern instruments?

In basic principle very little. In the plate camera the image was focused on to a ground glass screen via a bellows and a rack and pinion movement; the length of the exposure was controlled by simply removing and replacing a cap over the lens. The main difference between this and a modern camera is in the degree of convenience by which the image is viewed, focused and recorded.

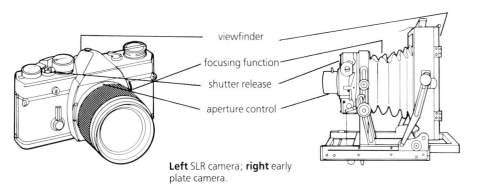

viewfinder
focusing function
shutter release
aperture control

Left SLR camera; **right** early plate camera.

■■
What is meant by parallax error?

It is the difference in the field of view between the taking lens of a camera and the viewfinder lens, and its effect is similar to that of viewing a scene through one eye and then through the other. It does not occur with an SLR or a view camera since both functions are performed by one lens.

■■
Is it possible to make an allowance for parallax error?

Most viewfinder cameras and twin lens reflex cameras have a line within the viewfinder that indicates the allowance that must be made at closer focusing distances where the problem is most evident. When you are using a camera on a tripod, however, you can also simply set the camera up using the viewfinder and then before taking the picture move the camera so that the taking lens occupies the same position as the viewfinder lens did when you were framing the picture.

■
What is the relationship between the f-numbers?

Each 'stop' smaller (which means a higher number) reduces the brightness of the image by half: for example, f11 is half the brightness of f8 and twice that of f16.

■
What do the f-numbers mean?

They are simply a way of standardizing the size of the aperture in relation to the focal length of the lens which is being used. The brightness of the image is affected by the distance the aperture is from the film as well as by its size so that a long-focus lens, for instance, would need a larger aperture, in terms of its actual size, in order to create an image of equal brightness to that created by a lens of a shorter focal length.

■
How can you tell how much of the subject will be in sharp focus?

With an SLR you can make a reasonable assessment by stopping the lens down manually to the pre-set aperture, although the image on the screen will only give an indication since the exact range of sharpness will be hard to discern with such a small and usually quite dark image. Alternatively, you can measure the extent of the depth of field by the use of the depth of field scale which is marked on the focusing mount of most lenses showing the nearest and furthest point of a scene which will be recorded sharply with the lens focused at a certain distance and set at a particular aperture.

■■
Why is there sometimes a different f-number marked on a lens?

This is usually a half or a third of a stop setting. The scale which is used on modern cameras is **f1.4 f2 f2.8 f4 f5.6 f8 f11 f16 f22 f32 f45 f64**. The setting f3.5, for example, is halfway between f2.8 and f4, and f1.7 is approximately halfway between f2 and f1.4.

■■
Why is it that the image in the old-fashioned type of camera was upside down but is the right way up in an SLR?

In the normal way when an image is projected by a lens on to a surface it is both upside down and reversed left to right. It is the combination of the mirror and the pentaprism used in the SLR which restores the image to its normal appearance. A camera such as a twin lens reflex or an SLR without a pentaprism will show the image reversed left to right but the right way up.

■■
How can I control the effect of perspective in a picture?

The main thing to remember is that by moving closer to a subject you will make it seem larger than more distant objects and in doing so will emphasize the effect of perspective. By moving further back you will make the nearer objects appear closer to their true size in relation to distant details, and this will lessen the perspective effect.

■■■
How are the f-numbers actually calculated?

They are calculated by dividing the focal length of the lens by the diameter of the aperture, so that a 100 mm lens with an aperture of 50 mm, for instance, would be called f2, and an f2 200 mm lens would need to have an aperture of 100 mm diameter.

■■■
How does a view camera control the perspective of the image?

If the camera is pointed at the subject at an angle, the verticals in the subject converge (right and below left). To prevent this, both the front and back panels of the camera should be raised so that they are vertical; this also has the effect of slightly distorting the image (far right and below right).

By means of the movable film holder and lens panel.

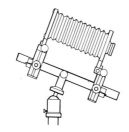 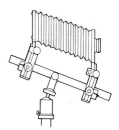

■■
What is a pinhole camera?

It is a camera without a lens in which the image is formed by light rays passing through a tiny hole.

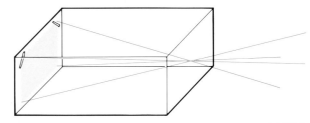

A simple pinhole camera made from a light-tight box with a pinhole in the front, and the light-sensitive material (printing paper) taped to the inside of the box at the back.

■■
How does a rangefinder work?

It has two windows separated by a distance of a few inches, one of which is reflected by a mirror or prism so that both images are seen superimposed. The distance from an object is measured by the angle at which the mirror or prism must be adjusted to make the two images coincide exactly.

■■
How do autofocus cameras work?

There are a number of different systems, but all use a measuring device to judge how far away the subject is, then activate a motor to move the lens to the best position for optimum focus. Most instant cameras use an ultrasonic pulse to measure distance, and time the delay until the echo returns. Compact cameras instead use a scanning infra-red beam, and autofocus SLRs judge distance by measuring the contrast of the image projected on the focusing screen.

In an autofocus camera, the point of focus is determined by a sonic pulse or an infra-red beam.

A 35mm autofocus SLR camera.

■■
Are there are any snags
with the autofocus
system?

Yes, quite a few. Some systems such as those which compare contrast can be inaccurate when a pattern is present in the image or in poor light. Another problem is that because the infra-red and ultrasonic devices will always focus on the nearest object within the central measuring zone this can give unsharp results if the composition is an unusual one or if the subject is not the nearest thing to the camera.

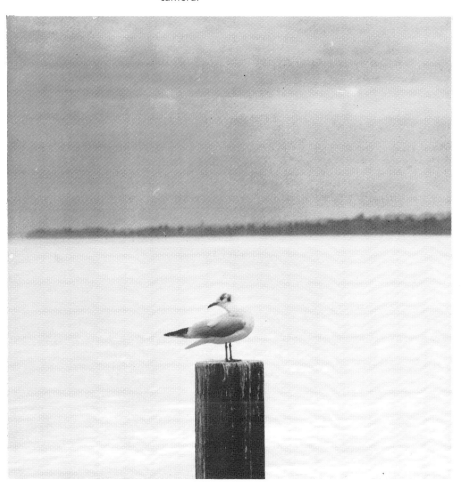

In this shot taken with an autofocus camera, the background details have not recorded sharply as they are outside the focusing zone. Nikon F2; 70 mm lens; 1/250 at f5.6; Ilford FP4.

15

Choosing a camera

■
What is the best way of choosing a camera?

First decide on your budget, then make a list of the type of subjects you are likely to want to take with the camera and the purpose to which you will want to put the pictures; this should help you to identify the type and film format of the camera you should buy. You should then try to see as many cameras of that description as possible since individual characteristics and handling will vary considerably.

■
Is it worth buying a camera with an interchangeable lens facility even if I only want to take snapshots?

Yes, because the fact that you are reading this book indicates that your interest may well develop beyond such basic pictures and the ability to alter the focal length of the camera lens will greatly increase the scope of your photography.

■
If I buy a secondhand camera am I going to have trouble obtaining the various up-to-date attachments?

If you buy a fairly old camera that is no longer in production this could certainly be the case, but even in these circumstances an earlier model of one of the major makes of camera such as Nikon is still likely to be compatible with many of the more recent accessories. However, you should avoid an obscure make or a discontinued camera range if you intend to build a system.

■■
Can an instant picture camera be used for anything more than just snapshots?

Yes. In fact, many professional and fine art photographers have turned to this type of camera for some of their work because it can be used to produce creative and unique images.

■■
How does the use of the pictures affect the film format of the camera?

For the production of small colour prints a cartridge disc or instant picture camera is suitable; for transparencies which are to be projected or for the production of larger prints a 35 mm camera should be considered; and for maximum image quality or for professional use a roll film or even a view camera might be a better choice.

■■
Will underwater cameras function just as well on dry land or do I need to have a separate camera for each?

Although you will be able to take pictures with an underwater camera quite satisfactorily on dry land, the degree of convenience is likely to be less than with a conventional camera since the functions and controls of such a camera are of necessity rather more crude in order to make underwater handling, viewing, and focusing easier.

■■
What is meant by a programmed exposure system?

It is an automatic system in which the camera selects the best combination of shutter speed and aperture according to the film speed and lighting conditions.

■■
Which is the best type of camera for action pictures?

A camera with a focal plane shutter will enable you to use much faster shutter speeds than one with a leaf shutter.

Nikon F2; 200 mm lens; 1/250 at f8; Kodak Tri-X.

■
What does the term 'multi-mode' mean when applied to an SLR?

Each mode offers you a different way of setting the camera's controls: shutter-priority auto mode gives the fastest shutter speed the light will allow, to stop action; aperture-priority auto mode gives a small aperture to keep more of the picture sharp from front to back; program mode gives equal weight to both controls, and is ideal for snapshots; and manual mode gives full control over exposure.

■■■
Is there any advantage in buying a well-known make of camera or are you simply paying for the name?

It is easier to hire or even buy a wider range of accessories for these cameras and also often easier to obtain a world-wide repair service.

■
Is there any advantage in buying, say, a 35 mm compact camera for use on a holiday as opposed to a cartridge or disc camera?

If you only want small colour prints then the advantage will be minimal for cameras of equal price. If, on the other hand, you want larger prints or if you want to project your pictures, then 35 mm is a much more suitable choice.

Nikon F3; 105 mm lens; 1/250 at f8; Ektachrome 64.

■
Can an inexpensive camera such as a fixed focus cartridge camera or an instant picture camera be used for serious photography?

If by 'serious' you mean the desire to take pleasing, well-composed pictures then that has little to do with the camera. A famous photographer once said that no photographer is as good as the simplest camera, and some of the greatest pictures were taken on very crude instruments. However, if you are talking about pictures with very high technical quality or pictures intended for publication or taken on assignment, then the answer is no.

Nikon F2; 105 mm lens; 1/60 at f4; Kodachrome 25.

■■
Is an SLR that has lots of modes better than one that has just a couple?

Multi-mode SLR cameras may have as many as seven modes in all, but some of these functions are highly complex and it is doubtful whether any photographer will make use of them all on a regular basis. Most people find that they use just one mode for most pictures, so money spent on buying 'extra modes' is often wasted.

■■■
Is a view camera the only type suitable for taking architectural pictures?

No, there are a number of cameras including many of the popular SLRs which can be fitted with a specially designed perspective control lens which offers a similar but more restricted facility to the movements of the view camera.

Nikon F3; 28 mm lens; 1/250 at f5.6; Ektachrome 64.

■■
Is it worth paying extra money for a 35 mm compact camera in order to have automatic focusing?

If you only ever take photographs in brilliant sunlight, then you probably will not notice the difference between a cheap fixed-focus camera and an autofocus model. In dull light, though, and especially indoors with flash, you will find that an autofocus camera takes sharper, clearer photographs.

■
I want a camera that will react quickly to unexpected situations where I will not have time for focusing and light readings, etc. What should I buy?

In the long run it will be your own experience and familiarity with a camera that will achieve this, not the camera. However, if you do not wish to devote the time and the trouble to developing such a technique then there is no doubt that in the short term an autofocus compact or a fixed focus cartridge or disc camera will be easier and quicker to handle than, say, an SLR.

An autofocus compact camera is ideal for capturing moments such as this.

■■
What does aperture priority mean?

It is a method of automatic exposure in which you set the film speed and the aperture, and the exposure meter determines the correct shutter speed.

■■
What is a shutter priority camera?

It is one in which you set the film speed and select the shutter speed, and the automatic exposure control selects the correct aperture.

■■
What type of camera is best for taking portraits?

It is best to have a camera with an interchangeable lens facility and a means of precise focusing since a long-focus lens is often an advantage for this type of picture.

Nikon F2; 150 mm lens; f16 with studio flash; Ilford FP4.

■■
What are the main differences between the professional models of SLR cameras like the Nikon F4 and other models in the range?

The two main differences are that the professional models are of a more rugged construction to withstand harder and longer use and that the viewfinder prism is detachable to allow a variety of viewing systems to be fitted to the camera for specialist applications.

Types of cameras

■
Is a viewfinder camera as good as an SLR?

Yes, in terms of the quality of the recorded image, but the viewfinder does not offer the same degree of accuracy as an SLR since the subject is seen from a slightly different position which causes parallax error. Also, since the image is not created by the camera lens the viewfinder camera can only show an approximation of the view.

■
Is the focusing of an SLR more accurate than that of a rangefinder camera?

A rangefinder is a very accurate method of focusing which shows the whole image equally sharp. The SLR, however, shows the effect of different planes of sharpness.

■
In what circumstances can it be better to use a rangefinder camera?

It can be easier to use in poor light, and when the noise of an SLR would be intrusive.

■
There are a lot of advertisements for cartridge and disc cameras that appear to be foolproof. Are they really as good as they seem and are they worth the money?

A combination of more advanced technology and improved film has reduced the possibility of disappointing results with a simple camera within a limited range of conditions, i.e. those required for most snapshot pictures. However, no matter how automated the camera, it is still necessary to use common sense and to understand something of the photographic process.

A disc or cartridge camera is the most suitable choice for snapshot pictures like this one.

■
What type of camera is suitable for an older child of about 15?

If you feel he is likely to become keen on photography and if you can afford it, I would suggest an SLR with both a manual and an automatic exposure facility, since this will enable him to learn the principles of camera technique and allow him to make greater use of the camera as his interest develops. However, if you feel that he is unlikely to take it very seriously and will just use the camera for personal records and for amusement, then a 35 mm compact would be a good choice.

■■
What is the best type of camera to buy for close-up pictures?

An SLR, since this offers the most accurate method of viewing and focusing, apart from a view camera, and can also be fitted with a variety of close-up accessories.

The use of an extension tube and an 85 mm lens with an SLR has meant that the camera can be focused at a very close distance.
Nikon F3; 85 mm lens; 1/125 at f8; Ektachrome 64.

■■
I have noticed that some professional photographers use a rangefinder camera like the Leica rather than the SLR. Why is this?

One reason is that the rangefinder camera is much smoother and quieter in operation and can be less obtrusive in some situations such as during a performance or a ceremony.

■■■
I am interested in taking panoramic pictures of landscapes. Is it worth buying a special camera?

Inexpensive cameras like the Kodak Stretch can now be bought or you may consider it worth hiring special equipment for specific pictures. You can also make effective panoramics by joining a series of prints.

■■■
I have been told that roll-film cameras always take sharper pictures than 35 mm cameras. Is this true?

Roll-film negatives and transparencies are up to five times bigger than negatives and slides on 35 mm film, so in theory they need less enlargement and will indeed appear sharper. The difference is only really apparent, however, when prints are made larger than 8 x 10 inches (20 x 25 cm).

■
**What type of first
camera would you
recommend as a present
for a child?**

It depends on the age of the child. If he or she is quite young, say 8 or 10, I would suggest a simple camera such as a cartridge or disc camera with fixed focus and automatic or symbol exposure settings so that the child will not be distracted from the visual pleasures of the medium; within the limitations of well-lit subjects and small colour prints the results should be encouraging enough to promote more interest. It would also be worth considering an instant picture camera as the ability to see results immediately will be a further spur to the child's enthusiasm as well as helping to introduce him to some of the magic of the process.

Instant picture camera
(right) and disc camera (far
right).

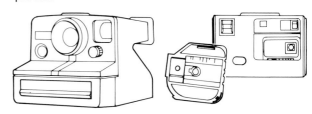

■■
**Do you consider an SLR
to be a better camera
than a viewfinder
camera?**

In a given price range the quality of the results will be virtually identical within the limits of the camera. However, an SLR camera can be adapted to handle a wider range of subjects and conditions.

■■
**Why is an SLR much
noisier than a viewfinder
camera?**

Because much more happens when you press the shutter; the mirror has to flip up out of the way to allow the image to pass through on to the film, the automatic iris has to stop down to its pre-set aperture, and the shutter has to open and close. With most SLRs the iris then reopens and the mirror returns to deflect the image back on to the viewing screen – and all of this takes place in a fraction of a second.

■■
**I would like to try some
underwater
photography,
do I need a special
camera?**

It is possible to buy both rigid and flexible housings to enable many normal cameras to be used underwater. However, a housing that is suitable for use at anything more than quite shallow depths would be fairly expensive and the degree of convenience would be greater with a custom-built camera. Both cartridge and 35 mm waterproof cameras are available for use in modest depths at relatively modest cost.

Right A transparent, flexible
housing with an inset glove
which can be used with a
normal camera.
Far right This simple
underwater camera is designed
for use at depths up to 16 feet
(5 metres).

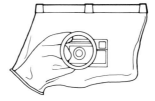

■■■
What are the advantages of the professional type of studio camera?

Arca Swiss 5 × 4; 210 mm lens; f16 with studio flash; Ilford FP4.

There are three main advantages: first, the large format, up to 8 × 10 in (20 × 25 cm), ensures the maximum possible image quality since only a small degree of enlargement is usually needed; second, each exposure can be processed individually for optimum results; third, both the film holder and lens panel can be moved, enabling control of both perspective and sharpness in the image.

■
Does the viewfinder camera have any advantages?

Because it is a less complex camera it can be made within a lower price range and as a rule it is both smaller and lighter. For most pictures of average subjects such as people and landscape views parallax error is not a particular problem.

In most situations this type of subject can be photographed quite satisfactorily with a viewfinder camera.

■
What is a twin lens reflex?

It is a type of camera that was very popular before the single lens reflex was introduced in its present form. It has a second lens similar to the taking lens which is mounted just above it on a common panel. A mirror deflects the image from this lens on to a ground glass screen where it can be viewed and focused as if it were the taking lens. The image is seen reversed left to right and its slightly different position from the taking lens creates a degree of parallax error. Most twin lens reflex cameras take roll film.

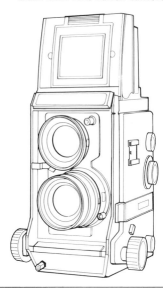

A twin lens reflex camera enables easy and comfortable viewing and focusing.

■
What is a compact camera?

The term means a 35 mm viewfinder camera, usually with automatic focusing.

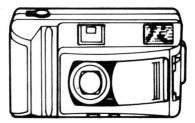

The small compact camera is ideal for snapshots and holiday photography while giving good results.

■■■
What is a dark slide?

It is a light-tight holder for use in a view camera which holds a sheet of cut film on each side. After the slide has been inserted in the camera back, a sliding protective sheath is removed prior to exposure.

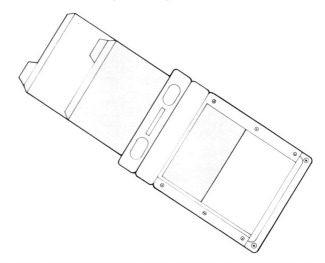

The illustration shows a double dark slide which holds two pieces of film.

■
Can I fit a zoom lens to my compact camera?

Some compacts like the Olympus AZ 300 now have built-in mid-range zoom lenses. Others have a tele-control that allows you to close in on distant details. Or you may be able to buy attachments that fit over the lens to create telephoto and wide-angle effects, much like a zoom lens.

This adaptor converts the lens of a compact camera into a telephoto.

Camera controls

■
What exactly is the aperture for?

Its prime function is to control the brightness of the image projected on to the film by adjusting the size of the hole through which the light passes, but it also affects the sharpness of the image.

■■
What is the difference between the X and M flash settings on a camera?

The X setting is for use with electronic flash and the M setting for use with flash bulbs or cubes.

■■
Can I use a slower shutter speed than that marked for flash with a focal plane shutter?

Yes, this is perfectly all right.

■■
Why is it not possible to use the fast shutter speeds when using flash with an SLR?

This is because most SLRs use a focal plane shutter which takes longer than the exposure actually set to pass across the film; if a shutter speed faster than that recommended for a particular camera is used then only a strip of the image will record.

■■
What is the difference between a focal plane shutter and a leaf shutter, and which is best?

A focal plane shutter consists of a fabric or thin metal blind with an adjustable slit which travels across the film plane inside the camera body. Its design enables it to give very brief exposures, as little as 1/4000 sec, and it also allows the lens to be removed without light reaching the film; this makes it a very convenient type of shutter for cameras with interchangeable lenses. The leaf shutter consists of metal blades, similar to those of an iris diaphragm, fitted within the lens; these open and close according to the setting to give a range of exposure times but with a minimum of usually 1/500 sec. This type of shutter will allow electronic flash to synchronize at all speeds but with cameras which have interchangeable lenses it is necessary for each lens to have its own shutter, which means they are more costly. As a general rule, the focal plane shutter is best for fast action subjects and makes the design of interchangeable lens cameras expensive; the leaf shutter offers more control when electronic flash is used.

■■■
Does the leaf shutter have any advantages over the focal plane shutter?

Yes. It will synchronize with electronic flash at all of the speeds whereas many focal plane shutters cannot be used at settings faster than about 1/125 sec.

■■■
How can the controls of a view camera be used to control the sharpness of the image?

The effect of depth of field can be increased with a subject on a receding plane by tilting the lens panel of the camera forward. What you are in fact doing is increasing the lens-to-film distance in the lower half of the picture where the subject is closer to the camera without altering it for the more distant plane at the top of the image.

These two pictures show the effect of tilting the lens panel from the vertical (right) into a forward position so that the whole of the image is in sharp focus (above).
Arca Swiss 5 × 4; 180 mm lens; f16 with studio flash; Ilford FP4.

■
**What is a double
exposure prevention
device?**

It is an internal mechanism in the camera that makes it necessary to wind on the film after an exposure to reset the shutter for the next exposure. This means that it is impossible to inadvertently make two exposures on the same piece of film.

■
**How can depth of field
be judged with a
compact camera?**

On the ring of most focusing mounts there are markings which indicate the depth of field obtained at different apertures, but there will not of course be a visual indication.

■■
**What is the B setting on
the shutter speed dial
used for?**

This enables the use of longer exposures than those marked on the dial. On this setting the shutter will remain open for as long as the button is depressed.

■■
**My SLR does not have a
depth of field preview
button. How can I judge
this effect?**

With many SLR cameras it is possible to make the lens stop down by partially removing it from its engaged position.

■■
**What is the purpose of
the mirror lock on my
SLR?**

In some circumstances it is necessary to lift the mirror clear of the film chamber to allow certain lenses such as some fish-eye lenses to be fitted. In addition where there is a risk of vibration as in macro photography the mirror can be lifted up out of the way and the camera allowed to settle before the shutter is fired to ensure maximum sharpness. This can also be useful for very long-focus lenses when a slow shutter speed is used; in this case the camera must be mounted on a tripod before it is aimed and focused.

■■
**What are the dots
between the ASA
numbers on the film
speed dial?**

These indicate stages of one-third of a stop, so that between 50 and 100, for example, you will have 64 and 80, or between 100 and 200 the stages 125 and 160.

■
**I used my autofocus
compact camera to take
some portraits in which
the subject is at the
extreme right of the
frame, and the prints
came back out of focus.
Is there a control to
correct this?**

Autofocus cameras focus on whatever is in the exact centre of the frame. If your subject was at the side of the frame, the camera would have focused on the distant background, so the face is blurred. There is a simple way round the problem: most autofocus cameras measure distance when you first press the shutter release, but they do not take the picture until you press harder. So you can point the camera at the subject, press lightly to focus, and then, still maintaining pressure on the button, turn the camera until the subject is off-centre before pressing hard to take the picture.

■■
What is the function of the depth of field preview button on my SLR?

When you view through an SLR you see the image produced by the lens at its widest setting. The depth of field preview button stops the lens down to the aperture you have pre-set and gives an indication of how much of the image will be in sharp focus.

Top This is the view normally seen through a camera; the use of the depth of field preview button (bottom) indicates the depth of field of the final image.
Top Nikon F3; 75 mm lens; 1/500 at f4; Ilford FP4.
Bottom Nikon F3; 75 mm lens; 1/30 at f16; Ilford FP4.

Loading and handling

■
**I accidentally opened the
back of my cartridge
camera. Will the whole
film be ruined?**

Only the frame actually in the gate and possibly the two
adjacent ones will be lost.

■
**What is the best way to
load a 35 mm camera?**

With all cameras it is best to do this in the most subdued
light you can find – never in sunlight. Always make sure
that both sets of sprocket holes are engaged and that
the film is slightly tensed before closing the camera
back. It is then best to fire off three frames before you
start taking pictures, making sure at the same time that
the film is winding on.

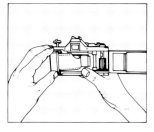

Choose the most subdued light
you can. Open the back of the
camera and pull out the rewind
knob. Insert the cassette with
the protruding end of the spool
at the bottom and push back
the rewind knob.

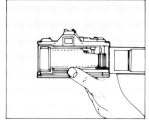

Pull out the film leader and
insert the end of the film into
one of the slots of the take-up
spool, ensuring that the
perforations engage the
bottom row of sprockets.

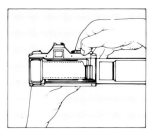

Wind the film on until the
perforations engage the row of
sprockets and the film is slightly
tensed.

■
**On one occasion I found
that the film had not
been winding on
although I had got
beyond 36 on the film
counter. How can I check
this in future?**

The film counter will usually work even when the camera is
empty. If you are sensitive to the operation of your camera
you should be able to feel when the film is not winding on
as it is easier to move the lever; also, the rewind knob
usually rotates when the film is being wound on correctly.

■
**On one occasion after
rewinding the film I
opened the camera to
find that it had not gone
back into the cassette.
What could have
happened?**

You probably pulled the film from its spool by winding on
too vigorously at the end of the roll. Always wind more
gently as you approach the last few frames.

■

I opened the back of the camera before rewinding the film. As I closed it very quickly will the pictures be all right?

If you were very quick indeed and if it was done in very subdued light it is just possible that a few of the first frames might be saved; otherwise they cannot be salvaged.

■

What can I do if I do pull the film off the end of the spool?

You must either take the camera to a dealer and ask him to unload it in a darkroom and replace it in the cassette or you can do it yourself, in a darkened bedroom under the bed-clothes, for example.

■■

I accidentally wound an unused 35 mm film back into the cassette. Is there anything I can do about it?

With a little care and patience you can retrieve the film. The easiest method is to insert a piece of double-sided adhesive tape stuck to a piece of thin card into the cassette, while gently winding the spool so that the tape grips the film. Once it has stuck, pull it out carefully.

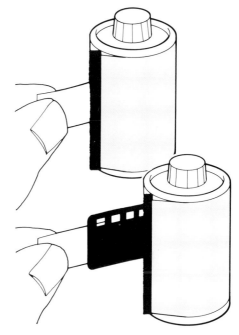

The film can be retrieved from the cassette with the use of a piece of adhesive tape.

■■

If a 35 mm camera is loaded carefully in the dark is it not possible to avoid firing off three frames and so get a couple of extra pictures on each roll?

Yes it is, but you would be advised not to use these pictures for anything important since apart from the danger of fogging the end frames are also rather vulnerable to damage at the processing stage.

■
How can I tell if 35 mm film has been wound back correctly?

You can usually tell by the slight loss of tension as it comes off the wind-on spool, but as a double check you can always count the revolutions of the rewind knob, giving one wind for each frame and a few more for good measure.

■
Is there a 'correct' way to hold a camera?

Yes, in so far as it should be held in such a way that it is firmly supported, is comfortable, and the controls can be reached easily without disrupting the grip. This will obviously depend to a large degree on individual cameras and individual people.

■
I find it much easier to hold my 35 mm camera steady in the horizontal position than in the vertical position. Is there anything I can do to improve this?

The illustrations show the way most people hold a horizontal camera and alternative ways of holding it upright. Try these different methods and see which suits you best.

From left to right Horizontal grip, vertical grip, and alternative vertical grip.

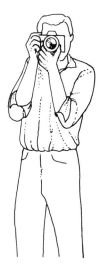 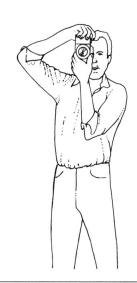 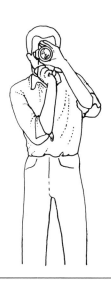

■
Are there are any special things to look out for when loading instant picture film?

Do it in subdued light and handle the pack by the edges to avoid pressure on the surface of the film.

■■
Is it more difficult to load a roll film camera than other types?

Not really, but roll film is if anything more vulnerable to fogging and special care should be taken to avoid loading in strong light.

■■
How helpful can a pistol grip be for holding a camera?

A pistol grip provides a convenient method of steadying and triggering a camera when using heavy or bulky accessories. The shot below was taken with a long-focus lens using a pistol grip.
Below Nikon F3; 300 mm lens; 1/250 at f8; Ektachrome 64.

It can be useful in some circumstances if you have a motor-driven camera as you do not have to move your grip to wind the film on.

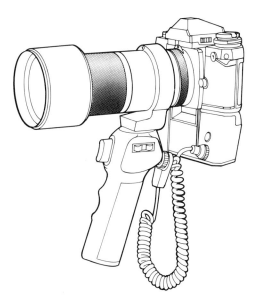

■
Are there any special problems in holding the small cartridge cameras?

Because they are so small and because most of them have a separate viewfinder you must ensure that your fingers do not intrude on the field of view as this would not be apparent in the viewfinder. Also, because they are so light you must be especially careful to hold the camera steady and to squeeze the shutter release gently in order to avoid camera shake.

■■
I wear spectacles and they often get in the way when I am using my SLR. Are there are any attachments I can use?

It is possible to fit eyesight correction lenses to the eyepieces of most SLRs. If you have an SLR with an interchangeable head it can be fitted with a right-angle viewing attachment which has adjustable focus for individual eyesight.

■■
Is it best to hold your breath when taking a shot?

Not if you hold it for more than a second or so as this is likely to induce wobble.

■■
Is it possible to take a half-used roll of 35 mm film from the camera and replace it later to use the rest?

Yes, indeed it is, but you must make a careful note of the frame number you last exposed (write it on the tongue with a marker pen), and when winding the film back be careful to stop rewinding the instant the film comes off the take-up spool as otherwise you will wind the take-up tongue into the cassette.

■■
What is the procedure for reloading a half-used roll of film?

Simply reload in the normal way, then with the lens cap on and in a darkened corner or under a coat, for example, fire off frames until you get to the unused portion of the film, firing off one more blank to be sure before shooting the rest of the roll.

■■
Are there any tricks in holding a camera when using a slow shutter speed in order to avoid camera shake?

Always try to find some additional support – even leaning against a wall or kneeling and resting your elbow on a knee can make it possible to use much longer shutter speeds with less risk of camera shake.

The low lighting conditions of this subject necessitated a slow shutter speed, and care was needed to avoid camera shake. Nikon F; 50 mm lens: 1/60 at f1.4; Kodak Tri-X.

Care and maintenance

■■
How much damage can occur if a camera gets wet?

As a general rule freshwater such as rainwater will not do much damage as long as it does not get into the mechanism and the camera is wiped dry. Seawater is potentially very harmful, however, and should be wiped off immediately with a soft cloth.

■■
Small particles of dust have collected in the viewfinder of my camera. Will this affect the pictures?

No, not at all, but they can be irritating. You may be able to blow them away with an air spray.

■■
What is the best way to clean a camera?

First, blow away any grit or dust with a compressed air spray or flick it off with a blower brush, then wipe with a soft cloth. This applies to lenses in particular.

For cleaning a camera you will need the following equipment: **1.** Compressed air. **2.** Anti-static gun **3.** Lens tissues **4.** Penknife **5.** Toothbrush **6.** Anti-static brush **7.** Lens cleaning fluid **8.** Lens cloth **9.** Cotton buds **10.** Blower brush.

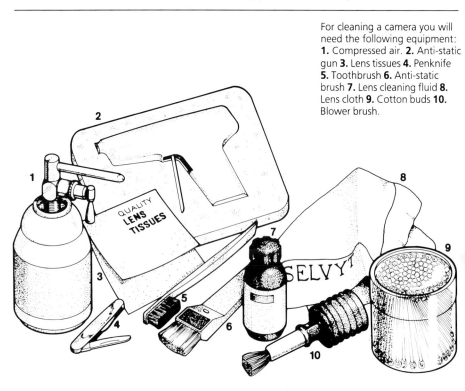

■■
Should I oil the mechanism of my camera?

Definitely not. Anything other than the removal of surface dust should be left to a camera mechanic.

■■
I am going on a long trip abroad. Will I be able to obtain batteries for my equipment or should I take a supply with me?

Batteries for most popular equipment are readily obtainable in the main tourist centres but if your travels will take you to out-of-the-way places you should take an adequate supply.

■■
Are there any special precautions that should be taken when storing a camera that will not be used for some time?

Ideally it should be kept in a clean, dry, dust-free place of moderate temperature. It would be advisable to remove any batteries and to leave the shutter untensed by firing it and not winding on, and to leave lenses with the irises open.

■■
I accidentally dropped my camera and fortunately there does not appear to be any damage. Should I send it to a dealer to be sure?

Modern cameras are surprisingly rugged and I have dropped mine many times with no ill-effects. It is therefore worth carrying out a check on it yourself before incurring any unnecessary costs.

■■
I think I may have damaged my camera when I dropped it. How can I check?

First make sure that there is no damage to the glass parts or mirrors, not forgetting the prism and viewing screen in an SLR; then ensure that the diaphragm blades are opening and closing and the auto iris is working; finally, check the exposure meter against another camera. If all these points seem all right then put a roll of film through as a final check, and also make a lens test to ensure there is no misalignment.

■■■
Will a camera be adversely affected by unusual climates?

As a rule, high or low temperatures alone will not affect the camera itself although battery performance can be impaired by low temperatures. Arctic conditions may require the use of special lubricants. However, the change from a high to a low temperature, or vice versa, may create condensation which can be very harmful since it can form inside the instrument. Dampness and humidity can cause similar problems.

■■■
How can I protect my camera from condensation in extremes of temperature?

You should keep your equipment in sealed plastic bags along with a special dessicant such as a silica gel to absorb any moisture.

Lenses

How lenses work
Choosing a lens
Types of lenses
Care and maintenance

How lenses work

■
How is it that the lens in a simple camera such as a cartridge camera appears only to be a simple lens and yet can produce clear pictures?

This is because only a small central portion of the lens is used and is controlled by a fixed aperture which improves its quality. In addition the negatives from cameras of this type are usually only enlarged to a relatively small degree where the inadequacies of the lens will not be too apparent.

■
Why is a camera lens so much more complicated than a magnifying-glass lens, for example?

Because a simple lens like a magnifying glass has many flaws and the image it projects will not be perfectly sharp and clear; in a good camera lens, several different individual lenses or elements are combined to cancel out these inherent flaws.

This cross-section of the type of lens used in an SLR camera shows the complexity of its construction and the many lens elements, which guarantees good performance.

■■
Why do lenses often appear coloured when you look into them?

This is because they are coated with a special material which reduces the amount of light reflected from its surface and thereby increases the amount of light which passes through on to the film.

■■
How does a camera lens actually work?

It works on the principle that light travels in a straight line; individual rays can be bent by the refractive qualities of the lens to converge at a given point and create a real image of a scene.

■■
What is meant by refraction?

This is a term describing the process by which light rays are bent or deflected when passing from one transparent medium to another of different density. Its effect can be seen quite clearly in the case of a straight object like a pole going into water.

■■
How do lenses of different focal lengths affect the perspective of a picture?

It is important to appreciate that the lens itself does not affect the perspective and that it is only the camera viewpoint which does this. However, the lens can have an influence on the choice and the use of a viewpoint: a wide-angle lens, for instance, will enable you to use a very close viewpoint including both close foreground details and distant objects, whereas a long-focus lens will not allow this and this *will* have an effect on the perspective.

The two pictures show the difference in perspective effect achieved with (right) a telephoto lens and (below) a wide-angle lens.
Right Nikon F2; 150 mm lens; 1/125 at f5.6; Ilford XP1.
Below Nikon F2; 20 mm lens; 1/250 at f8; Ilford XP1.

■
What is a zoom lens?

It is a lens in which the focal length can be continuously varied within fixed limits to provide a variable angle of view.

■
How is a fish-eye lens different from an ordinary wide-angle lens?

Firstly, it has a much wider angle of view than even an extreme wide-angle of conventional design – a true fish-eye lens has an angle of view of 180°. In addition, with a fish-eye lens straight lines are made to curve outwards the further they are from the centre of the image, and finally a true fish-eye lens produces a circular image within the film format.

■
What are the main disadvantages of a wide-angle lens?

Unless used carefully, it can easily create unwanted and unpleasant perspective effects. The considerable depth of field of a wide-angle lens and ability to include a wide area of a scene means that it can result in pictures which contain too many fussy and distracting details.

Right This picture illustrates the unpleasant perspective effects that can be caused by a wide-angle lens. The positive creative possibilities of this type of lens are shown in the shot below.
Right: Nikon F2; 24 mm lens; 1/250 at f5.6; Kodak Tri-X.
Below Nikon F2; 24 mm lens; 1/125 at f8; Ilford FP4.

■■
Is there any way of knowing what is a safe shutter speed to use in relation to the focal length of the lens?

A simple rule of thumb which will give a good indication of the minimum recommended shutter speed is to think of it in terms of a reciprocal of the focal length of the lens you are using; with a 200 mm lens you should not use more than 1/200 sec and with a 500 mm lens 1/500 sec, or the nearest setting.

■■
What are the f-stop markings on my lens mount at each side of the focus mark?

These indicate the depth of field that will be obtained at a given focusing distance according to the aperture selected.

■■
What is meant by an aberration in a lens?

This is a term used to describe the inability of a lens to produce a critically sharp image.

■■
What is meant by the angle of view of a lens?

It is the angle between the extremities of a subject that a given lens can include within the diagonal of the film format and depends on its focal length.

■■
Why do lenses have different maximum apertures?

This is because the more complex the design of a lens the more difficult and expensive it becomes to make the aperture wider. Another reason is that a wide aperture combined with a long focal length requires a great deal of glass.

■■
What is meant by the focal length of a lens?

This is the distance between the centre of the lens and the point at which it brings a distant object called infinity into sharp focus.

■■
What is a catadioptric lens?

It is another name for a mirror lens, a compact long-focus design.

■■■
There is a small red dot on the focusing mount of my lens. What is this for?

This is for use when you are shooting with infra-red film. The infra-red wavelengths are brought into focus at a slightly different point from those of visible light and this means that the lens should be reset so that the distance which is given by visual focus is transferred to the infra-red setting.

■■■
What is meant by barrel distortion?

This is a relatively common fault particularly with cheap, simple lenses. It is the inability of a lens to record straight lines, causing them to curve out towards the edges of the picture.

■■■
Does stopping down affect the performance of all lenses?

Yes. Most lenses improve as the aperture gets smaller to an optimum of usually about f8; this is generally more noticeable at the edges of the frame.

Choosing a lens

■■
Is there really much difference between lenses, apart from those in very cheap cameras, and is it worth spending more to get a good one?

Yes, there can indeed be a considerable difference in performance but it is a difference that will usually only be apparent when fairly large prints are made – say 8 × 10 in (20 × 25 cm) or more. You would be hard pressed to distinguish between an enprint made from a negative taken in a top-quality 35 mm camera and one made in a compact camera costing one-tenth of the price, but with an 11 × 14 in (28 × 36 cm) print, for example, the difference could be painfully obvious.

The × 10 enlargement of this print of a detail of a carved portal shows up quite clearly the difference in quality between the two lenses which were used.
Above Nikon F2; 50 mm lens; Ilford FP4. **Below** inexpensive compact camera.

■■
Why do some lenses cost so much more?

Because the better the quality of the lens the more accurately the individual elements have to be designed and made. Often very expensive glass is used, whereas the simple lenses in cheap cameras are often plastic.

■■
Are converter lenses worth considering?

A good-quality converter lens can be an effective way of increasing the focal length of a long-focus lens from, say, 150 mm to 300 mm but is less satisfactory with lenses of shorter focal length. Another point to note is that a converter which doubles the focal length of your prime lens will also reduce the maximum aperture by 2 stops. It is also advisable to use the lens stopped down 1 or 2 stops when using a converter to improve the performance.

■■
Is there any way of telling how good a lens is before you buy it?

Only by testing it. Some dealers do have such a testing service whereby individual lenses are given a certificate of performance. If you are buying from a small or a professional dealer it is sometimes possible to make a few test exposures outside the shop before committing yourself, but this is hardly feasible with the large discount stores.

■■
Do I have any form of redress if I get a poor lens?

If it falls outside the tolerances set by the manufacturer – and some lenses do slip through, despite quality control – a reputable dealer would replace it.

■■■
Would there be any disadvantages in replacing a range of fixed focal length lenses with a good zoom lens?

Assuming that by a range you mean from wide-angle to telephoto, the main disadvantage is that with present designs you would be unlikely to have as wide a range in a single zoom. Another drawback is that although you might have a reduction of bulk and weight in your camera bag, the zoom would be substantially heavier and more cumbersome to use than the individual lenses.

■■■
If you had to limit your outfit to just three lenses for general use, say holiday shots, which would you choose?

My personal choice would be a 24 mm, a 35 to 70 mm zoom, and a 75 to 150 mm zoom.

■■■
What would you suggest as an alternative to the standard lens offered with an SLR?

A mid-range zoom such as a 35 to 70 mm would be a useful alternative.

■■■
Is it worth paying more to get a wide-aperture lens?

With an SLR camera it can be an advantage simply because the image on the screen will be brighter. However, apertures like f1.4 are not used very often and the price difference between that and an f2 can be considerable.

■
**What is the difference
between a pre-set and
an automatic lens?**

An automatic lens enables you to focus and frame with the aperture wide open and then when the exposure is made the lens automatically stops down to the aperture you have set on the iris mount. With a pre-set lens, however, this must be done manually by twisting a ring which stops at the pre-set point.

■■
**What would you
consider is a good choice
of wide-angle lens for
general use?**

With a 35 mm camera I would suggest either a 24 mm or 28 mm, bearing in mind that you can always crop the picture if necessary but you cannot make it wider.

■■
**What does LPM mean on
a lens testing chart?**

This optical test chart can be used to check the performace of both lenses and films.

This stands for lines per millimetre and is a way of comparing the definition of different lenses. A number of exposures are made of the chart at various apertures and the performace of the lens is judged by its ability to record the lines printed on the chart at a given distance. In this way a lens that can record, say, 60 lines per millimetre resolving power is known to have more or better definition than a lens which can only record 40 lines per millimetre.

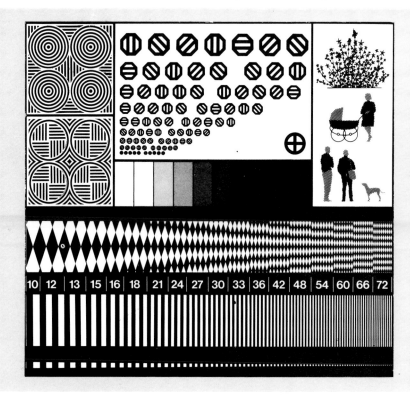

■■
I have a camera with a standard lens and want to buy an additional lens. Would a wide-angle or a telephoto be the best choice?

You will have to decide where your main interests lie. A long-focus lens is the best choice for subjects like portraits, sport, and nature pictures whereas a wide-angle is usually more useful for architectural subjects and some aspects of landscape and reportage photography. However, it is worth bearing in mind that you can always enlarge a portion of a negative taken on a standard lens to achieve a long-focus effect whereas you cannot obtain a wide-angle effect without a wide-angle lens.

The close-up portrait (right) was shot with a 200 mm lens: the landscape (below) required the use of a wide-angle.
Right Nikon F2; 200 mm lens; 1/60 at f5.6; Kodak Tri-X.
Below Nikon F2; 20 mm lens; 1/125 at f5.6; Ilford FP4.

Types of lenses

■■
When you buy a 35 mm SLR the lens which is supplied with it is usually a 50 mm. Is this the best and is it possible to have an alternative?

In principle, with most leading makes of SLR you can buy the body separately and have any other lens of your choice. However, the standard lens which is offered with it is usually reasonably priced and the 50 mm focal length is a good general-purpose optic.

Right Nikon F2; 50 mm lens; 1/250 at f8; Ektachrome 64.
Far right Nikon F2; 50 mm lens; ½ at f2; Ektachrome 400.

■■
What is a mirror lens?

This is a long-focus lens which uses mirrors in its optical design to reduce its size.

In a mirror lens, the image is formed by reflection from curved mirrors rather than by refraction through lenses.

A mirror lens.

■■
How does a wide-angle lens work?

The illustration shows how the field of view of the lens increases as its focal length becomes shorter. In the case of a wide-angle lens the focal length is substantially less than the diagonal measurement of the film format with which it is used; with a 35 mm camera the focal length of a standard lens is 50 mm, that of a wide-angle lens 35 mm or less.

Left The short focal length of a wide-angle lens gives an increased field of view, whereas a lens of longer focal length gives a smaller field of view (centre).

The resulting image obtained by each lens is shown above.

■■
Is it possible to use a lens made for a 35 mm camera on a different camera, a roll film camera for example?

No, because a specific lens will only give a certain area of illumination; this is usually a circle just slightly larger than the diagonal of the film format for which it is designed.

■■■
Are there any snags with a zoom lens?

A good lens will cost more than a standard lens and it is inevitably rather heavier and larger. A zoom lens will also usually have a smaller maximum aperture.

■■■
I have heard that a zoom lens is not as sharp as a normal lens. Is this true?

This certainly used to be the case but zoom lenses have now been developed and improved so that it would be hard to tell between a good zoom and a lens with a fixed focal length except in the most exacting circumstances, particularly when it is stopped down a little.

■■■
For what type of picture would an extreme wide-angle lens such as a 20 mm or an 18 mm be worth considering?

This type of lens invariably produces an obviously wide-angle look in a picture and is used either for deliberately exaggerated effects or in very confined spaces such as interiors.

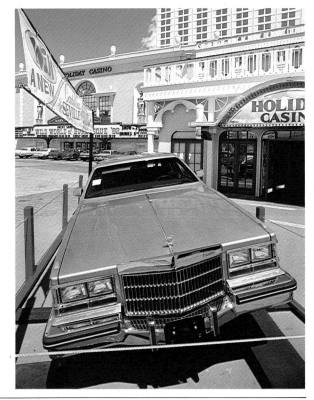

The use of a 20 mm lens and the choice of a fairly close viewpoint have emphasized the dimensions of the car to produce this interesting effect. Nikon F3; 20 mm lens; 1/250 at f8; Ektachrome 64.

■■
What is the difference between a telephoto lens and a long-focus lens?

A telephoto lens is simply a long-focus lens which has been designed optically so that its physical length is less than its focal length, making it more compact. In fact, all long focus lenses, and even some standard lenses, are now of the telephoto type.

■■
What is a macro focusing lens?

Most normal camera lenses focus down to somewhere between 1½ and 6½ feet (0.5 and 2 metres) depending on the focal length, but a macro focusing facility enables you to focus down to only a few inches.

■■■
Is a macro-zoom lens as good for close-ups as a true macro lens?

That depends what you are photographing. A true macro lens will produce much sharper results at close range, but you will notice the difference only with subjects that have a lot of very fine detail.

■■■
What is the best focal length of lens for portraits?

As a general rule, between 85 mm and 150 mm is a good compromise, and it is worth considering a 70 to 150 mm zoom since this can enable you to adjust the framing of your portrait without moving the camera; this is particularly useful when the camera is mounted on a tripod.

This close-up head-and-shoulders portrait was shot with a 70 to 150 mm zoom lens to facilitate framing of the subject. Nikon F2; 70–150 mm lens; f16 with studio flash; Ilford FP4.

■■■
What is a perspective control lens used for?

It is intended primarily for use with architectural subjects. It enables the optical axis of the lens to be raised (or moved to the side, or lowered) without tilting or angling the camera, which means that it can be adjusted to include, for example, more at the top of the picture and less at the bottom without the converging verticals that would result from tilting the camera upwards.

This shot shows the perspective effect when an ordinary lens is used. The vertical lines of the building have converged because the camera has been tilted upwards.

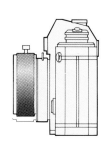

The use of a perspective control lens has overcome the effect of converging verticals and produced a less distorted image.

■■■
What is the best focal length of lens for sports photography?

This is a rather difficult question since a great deal depends on the sport. For arena sports such as football quite long lenses are usually needed – 400 mm or even 600 mm or more – but with subjects which you can approach more closely a 200 to 300 mm lens can be satisfactory. Remember, too, that when fast shutter speeds are needed you will have to use fairly wide apertures so that unless you are prepared to spend a great deal it may be better to settle for a more modest focal length with a wider aperture.

■■■
What are the relative merits of a long-focus and a mirror lens?

A long-focus lens is usually cheaper but has a relatively small maximum aperture and is rather unwieldy in the longer focal lengths such as 300 mm; although the mirror lens is extremely light and compact it usually has a quite small maximum aperture which is fixed.

■■
What is meant by a fast lens?

It is a lens which has a very wide maximum aperture for its focal length such as an f1.2 standard lens or an f2.8, 300 mm lens.

■■
What is a fish-eye lens?

This is a lens designed to give a field of view of up to 180°. This is achieved at the cost of a distortion whereby straight lines within the image become progressively more curved the closer they are to the edge of the frame. A true fish-eye lens gives a circular image within the film rectangle but there is also a semi-fish-eye lens which fills the frame.

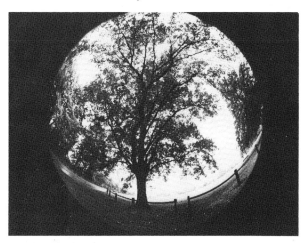

This circular image has been achieved by the use of a true fish-eye lens.
Nikon F3; 6 mm fish-eye lens; 1/125 at f8; Ilford FP4.

■■
Why am I not able to get the whole picture sharp when I use my telephoto lens?

This is because this type of lens has a much shallower depth of field than a standard lens.

The use of a telephoto lens in this shot has meant that while the main subject is in focus, the background details have not recorded sharply.
Nikon F2; 210 mm lens; 1/250 at f5.6; Kodak Tri-X.

■■
I have recently bought a long-focus lens but I am rather concerned because the pictures are sometimes not very sharp. Could this be due to the lens?

A more likely cause is camera shake. This problem is much greater with a long-focus lens and you will find that you will need to use faster shutter speeds to avoid it. If you make a few exposures with the camera mounted on a tripod you will be able to tell whether the problem is due to camera shake or whether the lens is faulty.

■■
What is an achromatic lens?

It is a lens corrected for chromatic aberration, the inability to bring light rays of different colours into sharp focus on the same plane.

■■■
What is the best focal length of lens for animal and bird photography?

Essentially the same considerations apply here as to sports photography if you are dealing with creatures in the wild. For domestic animals, however, and also perhaps zoo shots, a lens of 70 to 150 mm is a more practical choice.

The different demands of the subject in these two shots have dictated the choice of lens in each case.
Above Nikon F2; 300 mm lens; 1/250 at f5.6; Ilford FP4.
Right Nikon F2; 150 mm lens; 1/250 at f5.6; Ilford FP4.

■■■
I would like to try some shots with a magnifying glass but how can I work out the f-number?

You can work this out by first establishing the focal length of the lens. Focus the sun on to a piece of paper and measure the distance from the lens to the paper; next measure the diameter of that part of the lens you are using, and divide this into its focal length. This will be the f-number. With a focal length of, say, 10 cm and an effective aperture diameter of 2 cm your f-number will be f5.

■■
What is a Fresnel lens?

It is a lens which is formed of a series of convex, concentric rings on a flat piece of glass or plastic. It is used in spotlights and in viewfinder screens to make the image brighter at the corners.

A spotlight fitted with a Fresnel lens.

■■■
What is an anamorphic lens?

It is the type of lens used for Cinemascope movies. The image is compressed in one dimension to give a squeezed effect, then projected through a second lens which stretches it back to a natural appearance.

■■
Do I have to give 2 stops extra when I use a telephoto converter lens?

The extra exposure needed depends on the gain in focal length over the prime lens which a converter gives. A converter which doubles the focal length will need 2 stops extra, a X1.4 converter which increases the focal length by 50 per cent will need 1 stop extra, and a converter which increases the focal length by 300 per cent will require 3 stops extra.

■■
Do I get more depth of field when I use a telephoto converter or can I use the depth of field scale as it is?

The depth of field scale no longer applies when you fit a converter, and in fact there will be less depth of field than with the prime lens alone at the same aperture. However, since the converter effectively reduces the marked apertures – i.e. with a X2 converter the marked f8 will actually be f16 – the difference between the actual depth of field and that indicated on the scale for the marked setting will not be very great.

■■
Why are so many f-stops lost on zoom, wide-angle and telephoto lenses?

Because it is both more difficult and more costly to design complex lenses with wide maximum apertures.

Are zoom lenses suitable for portrait photography?

Zoom lenses are particularly suitable for portrait photography because they enable the framing of the subject to be adjusted precisely without moving the camera, which is very useful when it is mounted on a tripod.

Nikon F; 150 mm lens; f16 with studio flash; Kodak Tri-X.

Care and maintenance

■
Is it all right to clean camera lenses with a cloth meant for spectacles?

You should not use this type of material to clean coated camera lenses as it may affect the properties of the coating.

■
If the lens gets smeary should it be cleaned with a cleaning fluid?

It is best to avoid using these fluids if possible. A gentle wipe with a lens tissue or a special lens cloth should be enough.

■■
Should a lens need overhauling and do lenses need to be tested periodically?

There is no reason why a lens should need any attention unless it is dropped or damaged, apart from possibly the focusing ring needing to be tightened a little if it gets slack through heavy use. The iris mechanism can sometimes become faulty and it is wise to check this occasionally. A lens with a leaf shutter should also be checked for accuracy and cleaned periodically.

■■
Is there any point in having a lens re-polished and can this be done easily?

The process of re-polishing and subsequently re-coating a lens is expensive and relatively few services of this type are now available. It would only be worth while for a quite valuable or rare optic since it would probably be cheaper to replace a normal lens.

■■
There is a small scratch on the front element of my lens. Will it affect the pictures, and what can I do about it?

A small individual scratch is unlikely to have any noticeable effect on the performance of the lens and can be ignored. However, a general abrasion can affect it but this can usually be removed by having the lens re-polished. Your camera dealer will be able to advise you.

■■■
I have read that lenses should be cleaned as little as possible to avoid scratching, yet mine seems to get smeary very frequently. What should I do about it?

One solution is to keep a UV filter on the lens at all times and to clean this instead. It is relatively inexpensive to replace the filter if it is scratched or damaged.

■■■
What is the best way to test a lens?

Photograph something flat with a lot of fine detail (an open newspaper), ensuring that the camera is perfectly square. The subject should be fairly close – about 6½ feet (2 metres) – so that depth of field is minimal. The camera should be mounted on a tripod and focused accurately; make the exposure with the aperture wide open, then make another negative with the aperture stopped down.

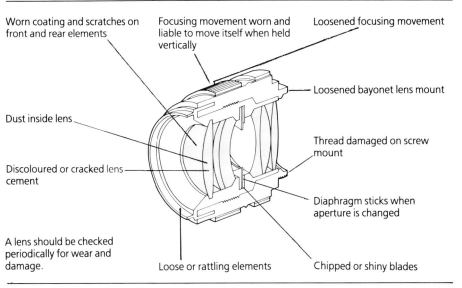

Worn coating and scratches on front and rear elements

Focusing movement worn and liable to move itself when held vertically

Loosened focusing movement

Loosened bayonet lens mount

Dust inside lens

Thread damaged on screw mount

Discoloured or cracked lens cement

Diaphragm sticks when aperture is changed

A lens should be checked periodically for wear and damage.

Loose or rattling elements

Chipped or shiny blades

The procedure for cleaning a lens is shown below.

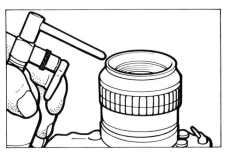

The surface of a lens should be treated with care. First remove any dust with compressed air.

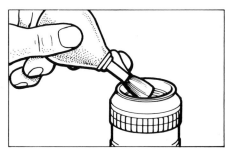

Dust can be removed from corners with a blower brush.

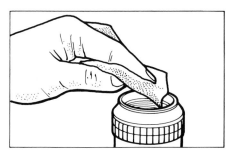

When all the dust and grit are removed the lens should be wiped with a clean lens cloth.

An ultra-violet filter should be fitted on to the lens to protect it from scratches.

Film

How film works
Choosing and using film
Specialist film

How film works

■
What is it that makes film sensitive to light?

It is a thin layer of silver salts called halides which is coated on to a plastic base and covered with a protective layer of gelatin.

■
Why does film have to be developed before you can see an image?

Because after the brief exposure in the camera there is no visible change and at this stage the image is latent. The chemicals in the developer change the silver halides into black metallic silver to produce a visible image.

■■
How is colour introduced into the film?

Colour film consists of three separate emulsions coated on top of each other, each made sensitive to one particular band of the spectrum, red, green, and blue. These are in turn coupled to the appropriate dye colour, which is the opposite or negative of the original colour, i.e. red is recorded as a mixture of green and blue called cyan, green as a mixture of red and blue called magenta, and blue as a mixture of red and green which is yellow. On processing, the image represents a negative version of the subject in both colours and tones. This is then printed on to a similar emulsion on an opaque base to produce a colour print in the original tones and colours.

■■
Why is it not possible to see the true colours when you look at a colour negative?

Because a special masking layer is incorporated into the film to correct inherent faults in the dyes and this has a strong orange tint.

The orange tint of this colour negative is caused by the masking layer in the film.
Pentax 6 × 7; 150 mm lens; ½ at f16; Vericolor II.

■■
How does colour transparency film work?

It is essentially the same as colour negative film except that the reversal of colours and tones takes place during processing and the negative image is bleached away.

■■■
What is colour temperature?

This is a way of measuring the colour quality of a light source and is expressed in degrees Kelvin (°K). It is based on the temperature to which a metal must be heated in order to take on a colour which matches that of a particular light source; the lower the temperature the more orange it will appear, and the higher the temperature the more blue it will be.

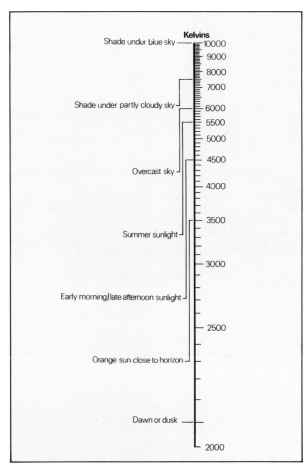

Kelvins

Light source	Kelvins
Shade under blue sky	10000
	9000
	8000
	7000
Shade under partly cloudy sky	6000
	5500
	5000
	4500
Overcast sky	4000
	3500
Summer sunlight	3000
Early morning/late afternoon sunlight	2500
Orange sun close to horizon	
Dawn or dusk	2000

The chart shows the colour temperature of various familiar light sources

■■■
Is it possible to measure colour temperature?

You can buy a colour temperature meter which operates on a similar principle to an exposure meter but measures the colour temperature instead of the brightness. However, it is only necessary for the most critical work.

■
What does film speed actually mean?

It is simply a means of expressing the relative sensitivity of a particular emulsion; a film with twice the speed is twice as sensitive and requires half the exposure to produce the same result.

■
Why is it that even when using the same film some pictures appear more grainy than others?

Probably because of the subject or the lighting; grain will show up more in areas of even mid-tones and less where there is detail or pattern, for instance, and it will also be increased by over-exposure or over-development with black-and-white film.

■■
What is grain?

These are the exposed and developed silver halides which have been converted to metallic silver and made visible by enlargement.

A twenty-fold enlargement has made the grain clearly visible in this image.
Nikon F2; 105 mm lens; 1/250 at f8; Kodak Tri-X.

■■
Does push-processing affect the quality of the image?

Nikon F3; 105 mm lens; 1/125 at f4; Kodak Tri-X updated to ISO 800.

Yes, this technique will increase both the contrast and the grain of the image, resulting in a general lowering of the image quality. In some situations this can be used to enhance the atmosphere of a picture.

■■
What do the words 'tungsten' and 'daylight' mean on film boxes and cassettes?

These words refer to the type of light in which the film will give its best results. To get perfect colour with daylight film, you must take pictures either by daylight, or using flash. Tungsten film gives its best results when the subject is illuminated by light bulbs. The differences are most marked with slide film, and in practice negative film has so much latitude to light of different colours that you can use it to take pictures under almost any lighting conditions, and still get acceptable results.

■■■
How can I alter the contrast of black-and-white film?

This can be done relatively simply either by the use of a 'soft working' developer or by reducing the normal developing times, in which case an increase of exposure would be needed to compensate.

■
**How does instant picture
film work?**

The individual sheets of film contain a pod of jellied processing chemicals which are activated by pressure after the exposure has been made.

■
**Why is film speed
important?**

Because exposure can only be calculated relative to the brightness of the subject and the speed of the film. By knowing the speed of the film and setting it on the camera or meter, the variations in subject brightness can be adjusted by means of the aperture and shutter speed to maintain the same level of exposure.

■
**What does the ISO
number mean?**

This is intended to take the place of the other film speed numbers and combines the ASA and DIN numbers so that ISO 200/24° is the same as 24 DIN or 200 ASA.

■
**What happens if slide
film balanced for
tungsten light is shot in
daylight?**

The resulting pictures will have a strong blue colour overall.

The strongly blue cast of this still-life picture was caused by using tungsten film with daylight.
Pentax 6 × 7; 150 mm lens; 1/30 at f8; Ektachrome 160 tungsten film.

■■
Does the contrast vary in different types of colour films?

To some extent yes. Colour negative film has a rather lower contrast than colour transparency and as a general rule fast films have a lower contrast than slow fine-grained films.

■■
What do the letters ASA stand for?

The American Standards Association.

■■
What does ISO stand for?

The International Standards Organisation.

■■
What does DIN stand for?

Deutsche Industrie Normen, German Industry Standards.

■■■
How can I uprate the film speed if I do not do my own processing?

Most professional laboratories offer a service of increasing film speed at a small extra cost.

In this close-up shot taken at a children's party, Ektachrome 400 film has been uprated to ISO 800/30°.
Nikon F2; 50 mm lens; 1/125 at f2.

■■■
What is meant by acutance?

It is a measurement of image sharpness and refers to the transition of tone between areas of different density in the image; the more sudden the transition, the higher the acutance and the greater the apparent sharpness.

Choosing and using film

■
What is the best speed of film for general use?

Nikon F2; 150 mm lens; 1/250 at f8; Ilford FP4.

For both black-and-white and colour, a film with a speed in the range of ISO 100 and ISO 200 is a good compromise between sensitivity and image quality, and is fast enough to cope with most subjects under reasonable lighting conditions. If you use colour print film in a non-adjustable camera, you will get a higher number of successful pictures by using a faster film – say ISO 400.

■

I have a simple camera; would it be best to use colour negative or colour transparency film?

Unless you particularly want transparencies as opposed to prints, negative film would be the best choice since it has a much greater tolerance to exposure error.

■

For how long can film be stored and in what conditions?

This varies according to the film type, and the official expiry date is marked on the packets (in general, black-and-white film has a longer shelf life than colour). However, the expiry date presupposes correct storage, which means cool and dry conditions; refrigeration is recommended for any film not intended for immediate use.

■

Is it possible to tell if film has deteriorated?

Apart from the expiry date there is no real way of telling, although the state of the packs may be an indication; faded or battered packs would indicate that the film was not stored correctly.

■■

I want to experiment with black-and-white photography. What would be the best choice of film?

I would recommend that you start with Ilford XP2. It has a wide exposure latitude and can be processed at your usual photolab to produce black-and-white (or sepia) enprints in the same way as colour negative materials.

■■

Is it best to use daylight film or artificial light film when shooting with fluorescent lights?

With most types of tubes in general use daylight film is best. However, it will require the use of colour correction filters as most types of daylight film produce a pronounced green cast; a CC30 or CC40 Magenta is the usual one.

■■

Can artificial light film be used for shooting with ordinary domestic bulbs?

You can use film balanced for artificial light quite normally with light bulbs, but with slide film the results may look slightly too warm. This can be cured by fitting a blue 82A filter over the lens.

■■

Would it be worthwhile buying a large quantity of film at a time or would it deteriorate?

Provided you use it before the expiry date and it is stored properly (preferably in a refrigerator), it would be an advantage since individual batches of film can vary in both speed and colour quality. You may also be able to buy more cheaply in quantity.

■■

I have some rolls of film which are well past the expiry date. Should I not risk using it?

If it is all the same type and batch try out one roll as a test, or alternatively use it for experiments or effects where the colour quality and speed will not be too critical.

■■

What are the photographic effects of using old film?

As a general rule it will lose speed and there will be a marked colour bias, usually towards green. The contrast is also often reduced, causing degraded shadows and weak maximum density.

■■
What is the best film to use if a scene is lit with a mixture of tungsten and daylight?

This brightly lit indoor scene has been shot with daylight film to produce the warm colour cast. Nikon F; 50 mm lens; 1/30 at f4; Ektachrome 200.

You should select the film which is balanced to the predominant light source. If the sources are more or less equal then as a general rule it is best to use daylight film as an area of orange colour cast can look more pleasant than a blue one.

■■
If I keep my film in a refrigerator is it all right to use it straight away?

No, you should allow a couple of hours for it to reach room temperature.

■■
I have inadvertently taken some pictures in artificial light using daylight film. What will happen, and can I do anything about it?

The result will be a strong orange cast, and the only thing you can do is to make prints or duplicate transparencies from them and use heavy blue filtration to offset some of the effects of the cast. You will have to use a filtration equivalent to the 80B tungsten-to-daylight conversion filter.

The predominantly orange cast in this picture was caused by using daylight film in artificial light.
Nikon FE2; 28 mm lens; 1/4 sec at f5.6; Ektachrome EPL 400D.

If I want both prints and transparencies what is the best colour film to use?

It is possible to make colour transparencies from colour negatives, and, of course, colour prints from colour transparencies. However, it will cost more to have good-quality colour prints made from transparencies professionally (though it is also quite simple to make your own), and the transparencies made from colour negatives will not be of such good quality as originals. It is therefore not a straightforward decision and you will need to consider both your prime need and the relative costs.

How can transparencies be made from colour negatives?

It is possible to buy a colour print film which is used in a similar way to a colour print paper. A useful alternative method which gives quite good results is simply to copy a good-quality print on to transparency film.

Are some films more suitable for push-processing than others?

Yes. Colour transparency film is better than colour negative film and as a general rule fast films can be pushed more, and more satisfactorily, than slow films.

To produce this shot, Ektachrome 200 film was uprated to ISO 400/27°. Nikon F; 50 mm lens; 1/30 at f2.8; Ektachrome 200.

Will the X-ray equipment at airports affect processed film?

No, it is quite safe to expose transparencies and negatives to X-rays as long as they have been correctly processed.

Is colour negative or colour transparency the better film to use for available light photography?

The very fast colour negative films now available are a good choice for mixed lighting conditions and sources of unknown colour quality as the balance can be adjusted when the prints are made.

Is there any point in trying to use film that is out of date?

All unexposed film deteriorates with age. The speed of the deterioration depends on the type of film and the conditions in which it has been stored. Film which has been stored carefully or kept in a refrigerator may well be perfectly satisfactory long after its official expiry date whereas badly stored film could be adversely affected in that time.

What is the best colour film to use if I want to make the occasional black-and-white print?

Colour negative film, since you can print directly on to a colour-sensitive black-and-white paper. With a colour transparency film, you first have to make a black-and-white negative.

Nikon F2; 24 mm lens; 1/125 at f5.6; Vericolor II.

■■■
What is reciprocity failure?

The film speed printed on the carton and cassette is only accurate for shutter speeds of half a second or less. Loosely speaking, reciprocity failure is the drop in film speed that occurs when you use exposures of a second or longer.

■■■
What criteria govern the choice of a particular film format?

The choice of the 35 mm format suits both the subject and approach of this shot. Nikon F; 200 mm lens, 1/250 at f8; Kodak Tri-X.

There are a number of considerations, the most obvious being image quality. Where fine detail must be recorded very sharply and/or big enlargements are to be made, then as a general rule the larger the film format the better; the difference between a contact print from, say, an 8 × 10 in (20 × 25 cm) negative and an enlargement of the same size from even a very fine-grained 35 mm negative would be quite considerable. However, film format does have other implications as it tends to impose a certain style and quality on a photograph. The slightly gritty quality of a Tri-X 35 mm negative, for example, is often a contributory factor to the visual quality of a particular type of image such as war or documentary photographs.

■■■
What is the difference between Type A and Type B artificial light balanced film?

Type B film is optimized for use with tungsten studio lights which have a colour temperature of 3200°K. Virtually all tungsten balanced film made is now of this type. Type A film is balanced for photoflood bulbs, which have a rating of 3400°K. In practical terms, the difference between the two types is insignificant.

■■■
How can I uprate the speed of a film?

With black-and-white film you can buy special speed enhancing developers or use extended development times, with colour transparency film you can modify the processing times according to the instructions. In this way the film speed can be increased in precise increments of a third or a half stop.

Specialist film

■■
I am not clear what 'false' colour means in the context of infra-red photography. Can you explain this?

Infra-red colour transparency film is sensitive to a mixture of both visible light and the invisible infra-red radiation. This means that while some parts of a subject may appear as almost normal colours, others which reflect infra-red light strongly will be startlingly different; this includes green foliage which can record as magenta or red.

These two pictures show the difference in effect that can be achieved by using infra-red colour transparency film.
The top picture was taken with ordinary colour film, and the other with a special infra-red film which has resulted in the strange colour effects.
Above Nikon F3; 75 mm lens; 1/250 at f8; Ektachrome 64.
Below Nikon F2; 75 mm lens; 1/125 at f8; Infra-red Ektachrome.

■■
I want to do some infra-red photography of plants. Assuming I have the correct film and filters what is the correct exposure?

Since infra-red film is designed to respond to the invisible wavelengths of light, an exposure meter is theoretically not very appropriate. However, in practice and under normal lighting conditions the meter will give a good indication for the basis of a test exposure, using the manufacturer's recommended ISO rating for the film and filter in use. You will find, however, that with both the black-and-white and colour versions a 'correct' exposure is not quite such an objective consideration as with ordinary materials. The creative effect of the film will, in fact, vary considerably with different exposures and under different conditions so that the real answer is to experiment and to bracket exposures quite widely.

■■■
Are there any special problems in using infra-red film?

Yes. The black-and-white version in particular must be loaded and unloaded in darkness, and some plastic camera bodies will allow it to fog. It is also best to use a metal developing tank or to process the film in darkness. Use a small aperture or use the infra-red focus mark on the lens mount as infra-red rays are focused at a slightly different point from visible light. The infra-red colour transparency film must be processed in the old E4 chemicals which means that you will either have to find one of the few laboratories still using this method or process it yourself.

The interesting effect of this black-and-white landscape was produced by using infra-red film and a red filter.
Nikon F2; 20 mm lens; 1/125 at f5.6; Kodak Infra-red black-and-white film; red filter.

■■
What is meant by panchromatic film?

This is a term used to describe film which is sensitive to all colours in the visible spectrum.

■■
What is meant by orthochromatic film?

This is film which is not sensitive to red and orange light.

■■
Should fast film always be used when taking pictures in poor light?

The only occasion when it is necessary to use a fast film is when poor lighting is combined with a need to use a fast shutter speed, say with a moving subject. If you have a static subject and are able to give longer exposures (with the camera mounted on a tripod), there is no reason why you cannot use a slow film.

■■
I would like to try some of the very fast colour films, like ISO 3200, but the film speed dial on my automatic camera only goes up to ISO 800. Does this mean that I can't use them?

Not at all, you simply set the film speed to ISO 800 and the exposure compensation dial to minus 2 stops. If you use an ISO 1600 film you should set the exposure compensation dial to minus one stop. Do remember, however, to reset the exposure compensation to normal when you have finished the roll of fast film.

The low lighting conditions have necessitated the use of a faster film speed, which has also emphasized the grain effect.
Nikon F; 50 mm lens; 1/30 at f2; Kodak Tri-X uprated to ISO 1600/33°.

■■■
What is chromogenic film?

It is the name given to emulsions that use dyes rather than metallic silver to form an image.

■■■
Are there any disadvantages with chromogenic films?

They have to be processed in special chemicals and at much higher temperatures than conventional black-and-white films and there is some doubt as to the permanence of the resulting negatives.

■■■
Is it possible to shoot black-and-white transparencies?

Yes, Agfa makes a film called Dia Direct which produces a direct reversal tansparency in black-and-white.

■■■
Do chromogenic black-and-white films need special processing?

For optimum results, films like Ilford XP2 and Agfa Vario XL should be processed in special chemicals, but they can also be processed like colour print films, and printed on colour paper. You may find that for a full roll of film this is cheaper than having black-and-white prints made.

■■■
What is inter-negative film used for?

It is designed for making colour negatives from colour transparencies so that C-type or neg. pos. prints can be made from the transparency instead of reversal prints.

Accessories

Studio equipment
Exposure meters
Tripods and supports
Specialist equipment
Filters and lens attachments
Flash-guns

Studio equipment

■
What is a photoflood bulb?

It is like an ordinary domestic bulb but is designed to give a greater light output in exchange for a much shorter life, usually about two to three hours.

■
Is it possible to take studio-type pictures using ordinary domestic light such as a table lamp?

Pentax 6 × 7; 150 mm lens; 1/15 at f11; Ilford FP4.

Yes, certainly, though it is slightly less convenient and more limiting, particularly in terms of light output. However, with small set-ups and static subjects such as a still-life, a table or desk lamp with a diffuser and a reflector could be used quite effectively, and for more output you could replace the ordinary bulb with a photoflood bulb. When using ordinary domestic bulbs for colour shots you will need to use a bluish colour correction filter as these bulbs are slightly warmer in quality than those for which tungsten film is balanced.

■■
What are the main uses of a spotlight?

It has two prime uses, one to create very dense hard-edged shadows and the other to create bright highlights.

■■
What are the main uses of an umbrella?

It is simply a convenient and portable method of providing a large, soft source of reflected light.

■■
What are the different types of light attachments and what are they used for?

The most commonly used types are barn doors for restricting and controlling the spill of light; a snoot or honeycomb for concentrating the light into a small area; a spot attachment for an even more concentrated pool of light; and a diffusion screen to create a softer light.

In this studio portrait a spotlight attachment has been used to create a greater concentration of light and sharp, hard-edged shadows. Nikon F2; 75mm lens; f11 with studio flash; Ilford FP4.

■■■
What are the advantages and disadvantages of flash over tungsten for studio lighting?

The advantages of flash are that the brief duration of the light virtually eliminates the risk of subject movement or camera shake, it generates less heat and constant bright light than tungsten and so can be more comfortable for models, and it produces light of a very consistent colour quality and brightness. The disadvantages are that it requires the use of a special exposure meter, you must wait between exposures for the flash to recharge, and your choice of aperture is governed by the power of the flash and its distance from the subject. Flash tubes are also more costly to replace. The disadvantages of tungsten are that it cannot be mixed so easily with daylight and you are obliged to use a different film when shooting in colour.

■
What is a boom light used for?

Pentax 6 × 7; 150 mm lens; f11 studio flash; Ektachrome 64.

It is a light on an extension arm (usually counterbalanced) which enables the source to be positioned directly above the model while the stand remains outside the picture area. It is used mainly for top lighting still-lives and to provide hair and rim lighting for portraits.

■■
What is a scrim?

It is an attachment for a tungsten light which reduces its power by a determined amount, say one stop, without affecting its colour quality.

■■
What equipment do I need to set up a home studio?

The ideal set-up that will enable you to photograph subjects such as still-lives, portraits, and nudes and give you the ability to create a variety of lighting effects consists of three light sources on adjustable stands. These can be either tungsten or electronic flash, a narrow beam reflector (preferably with a snoot or spot attachment), and at least one soft reflector such as an umbrella. You will need some means of diffusion such as a window-light or a simple tracing-paper screen and some form of background like the paper rolls supplied by professional dealers, and a means of supporting it. A boom stand would be a useful variation on the normal type of stand and a tripod should be considered a necessity. You will also need one or two large white reflectors made of cardboard or polystyrene.

What are diffusers and what are they used for?

A diffuser is a piece of frosted plastic or fabric which is placed in front of a light to produce a very soft illumination, creating only slight, soft-edged shadows.

Rolleiflex SLX; 150 mm lens; 1/125 sec at f5.6; Ektachrome 64.

What is meant by black light?

It is a term used for ultra-violet-light, fluorescent or filament bulbs which are coated with a filter to eliminate the visible wavelengths. They are used in theatres, discotheques, and window-displays.

How can I adjust the colour of tungsten lamps so that I can mix them with daylight?

Professional dealers sell the necessary colour conversion filter (80A for 3200°K to daylight and 80B for 3400°K to daylight) in the form of a large acetate sheet which can be fitted over the lights.

What is a swimming pool light?

It is a light fitted with a very large diffuser, usually about 6 × 4 feet (1.8 × 1.2 metres), designed to create a very soft, large, and even light source. It is used mostly in still-life, fashion, and room-set photography.

A swimming pool is a specialized light with a high output which is ideal for full-length portraits.

Exposure meters

■
**Can an ordinary
exposure meter be used
with electronic flash?**

No. You will need a special flash meter to read from the
very brief duration of the flash.

■■
**What are the different
types of exposure
meters, and are they
designed for different
uses?**

There are basically two different ways of measuring expo-
sure with a meter: by reflected light and by incident light.
The first method measures the light reflected by the sub-
ject and is the system used by meters that are built into the
camera; most hand-held meters are used in the same way.
An incident light reading is taken by aiming the meter at
the light source from the subject position and measuring
the light falling upon it; many hand-held meters can be
used for this as well but not built-in meters. Meters also
vary in terms of the area of the subject from which they
take a reflected light reading: an averaging meter reads
from the whole of the area that it can 'see'; a centre-
weighted meter reads from the whole area but with a bias
towards the details in the centre of the picture area; and a
spot meter reads from only a very small and precise area of
the scene. There is also a meter specially made for use with
flash which usually uses the incident light reading method.

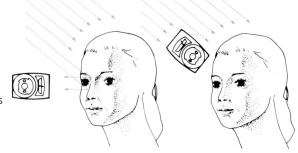

The illustration shows two ways
of taking an exposure reading
using a light meter; (right)
reflected light reading and (far
right) incident light reading.

■■
**I suspect that my
exposure meter is not
reading correctly. Is there
a simple way of
checking?**

A simple rule of thumb which will give a good indication is
that a normal subject which is lit frontally with bright
sunlight will require a shutter speed that is a reciprocal of
the ASA speed of the film when the aperture is set at f16:
i.e. with a 200 ASA film 1/200 sec at f16 and with 64 ASA
film 1/64 sec at f16, and so on.

■■
**Why do some exposure
meters need a battery
and not others?**

Because some meters such as the Weston use a selenium
cell which generates its own electric current according to
the intensity of the light. Although very reliable it is not as
sensitive as the battery-powered meters.

■■
Is it not possible to take an incident light reading with a TTL meter?

It is possible to buy an attachment similar to an invercone to fit on the front of a camera for incident light readings.

■■■
Is a TTL spot-meter better than an ordinary centre-weighted meter?

A TTL spot-meter bases exposure on a brightness reading from a very small area of the subject. This is useful when the subject is much brighter or dimmer than the surroundings: a situation which would mislead a centre-weighted meter. Spot-meters must be used with care, and for most subjects a centre-weighted meter is quicker and more reliable.

■■■
Is there any way I can use my TTL meter for taking flash readings?

If your flash units are fitted with modelling lights it is possible to work out an exposure factor for the modelling lights in relation to the flash and take your reading from these; for example, with your camera set on the right shutter speed for flash you might find that the aperture required for a correct exposure with the flash was perhaps 3 stops smaller than that for the modelling lights, so you simply take a reading in the normal way and stop down by 3 stops each time.

■■■
What is a spot meter used for?

It is a meter with a very narrow angle of view of only a few degrees and is used to measure the light reflected from a small and precise area of a subject.

■■■
What is the advantage of a separate meter over an integral one?

A separate meter can be used for taking incident light readings and is often more convenient to use for taking close-up readings particularly when the camera is mounted on a tripod. If your integral meter goes wrong then you will of course have to send the whole camera to a specialist repairer.

Nikon F2; 105 mm lens; 1/125 at f8; Kodak Tri-X.

Tripods and supports

■
I only have a simple camera so is it really worth having a tripod?

A tripod is one of the most useful accessories since even with a simple camera it can help you to take sharper and more accurately framed shots. It also allows you to use time exposures in poor light conditions such as night-time.

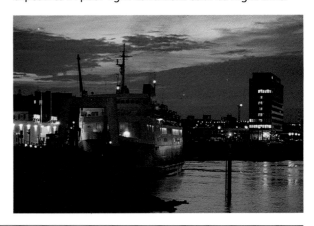

Nikon F3; 75 mm lens; 5 at f8; Ektachrome 400.

■
What is a monopod and what is it used for?

It is virtually the single leg of a tripod and is designed to steady the camera when using a long-focus lens or with slow shutter speeds that may cause camera shake.

■■
Is it possible to use a tripod very close to the ground?

Most tripods will not support the camera at less than their collapsed height, but with some types the legs can be completely splayed out to reduce the working height, and with others the centre column can be reversed so that the camera can be suspended below it. A ground spike is available for taking ground-level pictures in soft terrain and on a hard surface a small table-top tripod could be useful.

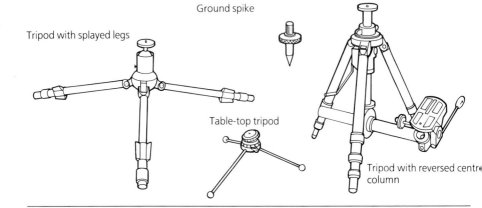

Ground spike

Tripod with splayed legs

Table-top tripod

Tripod with reversed centre column

■■
Is a monopod a suitable alternative to a tripod?

It can be very useful for borderline shutter speeds where camera shake might occur with an unsupported camera and it can be useful for steadying a long-focus lens, particularly when the camera needs to be moved quickly as in sports photography. It is of little use for shutter speeds of say 1/15 sec or longer, and of course no use at all for time exposures.

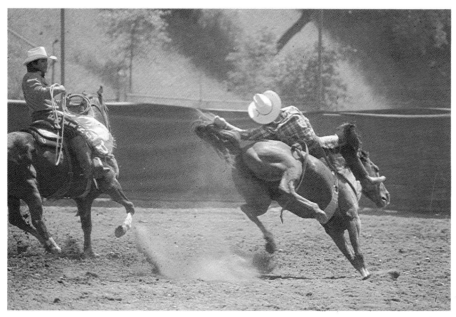

Nikon F3; 300 mm lens; 1/1000 at f5.6; Ektachrome 200.

A monopod (right) is a one-legged support for hand-held shooting (far right).

■■■
Are there any tripods, monopods, or clamps which can be used by photographers in wheelchairs?

There are a number of photographer's construction kits available which supply a range of tubes, clamps, ball and socket joints, and a variety of other accessories that can be combined in many different ways to cope with almost any situation, not just for cameras but also for lighting and so on.

Specialist equipment

■
What is a focusing screen and what is its function?

A focusing screen is a piece of glass with a ground surface which is designed to 'receive' the image projected by a lens. This enables it to be viewed from the other side, unlike an opaque screen such as a projector screen where the image is viewed from the same side as the lens that creates it.

■
What is the advantage of using a close-up lens?

It is the only way of focusing at closer distances with a fixed lens camera and unlike a bellows unit or extension tube does not require any increase in exposure.

■
Is it best to buy a soft case to hold equipment or a rigid suitcase type?

The suitcase type obviously gives more protection to the equipment and can be useful if you tend to travel from place to place. On the other hand, it is neither very comfortable nor convenient to carry on the shoulder, nor for actual use, and this is why most photographers select the soft case.

From left to right An aluminium case with foam insets; a rigid case with adjustable partitions; a soft bag with shoulder strap.

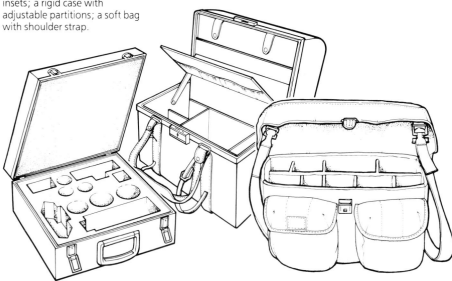

■■
What is the difference between an autowinder and a motor drive?

An autowinder advances the film after an exposure and will in most cases also allow continuous shooting by keeping the shutter release depressed at up to about two frames per second. The motor drive is a more powerful unit which in addition to exposing single frames will allow continuous shooting of up to six frames per second, or with some specialist equipment even more.

■■
Can I make instant film test shots using my 35 mm SLR camera?

Although you can fit an instant film adaptor to most roll-film cameras, Polaroid backs are available for only a few 35 mm cameras. However, a specialist camera mechanic may be able to adapt one to fit your camera, making Polaroid tests possible.

■■
What is the best type of close-up attachment?

A macro lens is the best way of shooting close-ups as not only does it have a much closer focusing facility than a normal lens but it is specially designed to perform well at close focusing distances. However, with a normal lens on an SLR a bellows or extension tube will also give good results especially when smaller apertures are used. A bellows unit has the advantage of greater flexibility in adjustment and focusing distance but is usually not coupled to the auto iris or exposure system of the camera whereas an extension tube can be.

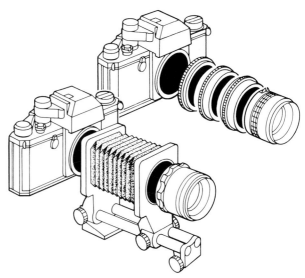

A bellows attachment (left); extension tubes (right).

■■■
What are bag bellows used for?

They are specially voluminous bellows designed for use with a wide-angle lens which allow freedom of movement on a view camera.

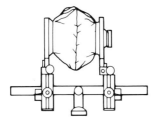

Bag bellows on a view camera.

Filters and lens attachments

■
Can effects filters be used on compact cameras or are they just for SLRs?

No, most of them can be used on a viewfinder camera. However, the effect will not be visible through the viewfinder and you will have to estimate the effect to some extent by holding the filter in front of your eye, rotating it to the optimum position, and then transferring it at that angle to the camera lens.

■
Can a polarizing filter be used to darken the sky when shooting with black-and-white film?

Yes. With a deep blue sky at the optimum angle the effect will be similar to that of an orange filter.

■
Is the exact effect of an attachment seen when viewed through an SLR?

With some attachments like the star-burst, the soft focus, and the multiprism the effect varies according to the aperture selected. Since most SLRs show the image with the aperture wide open it is necessary to stop the lens down manually to the setting you intend to use in order to judge the effect.

The striking, atmospheric effect of this dusk shot has been enhanced by the use of a star-burst filter and a tungsten light film.
Nikon F3; 105 mm lens; 1/8 at f11; Ektachrome 160 tungsten film.

■■
What is a diffraction grating?

It is a glass or plastic filter engraved with a fine grid which acts like a prism splitting light up into its component colours. It is sometimes described as a colour-burst filter.

A diffraction grating has been used to add drama and interest in this shot of Dover castle. Nikon F2; 50 mm lens; 1/60 sec. at f5.6; Ektachrome 64.

■■
What is a reversing ring?

It is a device that allows a camera lens to be mounted back to front on the camera so that it can focus at closer distances for close-up shots and give improved definition.

■
I took two pictures, one with and one without a red filter, yet the prints look identical. Why?

The machines used to print colour negatives work on the principle that all pictures have equal amounts of each colour. The machine 'thought' that your red picture was a mistake, and compensated by dialling in extra green filtration. If you want to use special effects filters, it is best either to use slide film, or to print negatives in a home darkroom.

■■
What is a sky-light filter?

It is a slightly warm coloured filter designed to reduce the blue cast on colour film by absorbing ultra-violet light. Its effect is rather stronger than a UV filter but not as strong as an 81A.

■
What is a multiprism?

This is a lens attachment which has a number of facets like a prism and creates repeat images around the central image upon which the lens is focused. It can be bought in a variety of configurations such as a number of images in a row or three, four, or five images surrounding the prime one.

Nikon F2; 75 mm lens; 1/125 at f5.6; Ektachrome 64.

■
I want to buy a few filters to see if I can improve my pictures. Which would you suggest?

I would suggest an 81A, a polarizing filter, and a neutral graduated filter. If you want to shoot black-and-white pictures, a red or orange and perhaps a green would be useful.

■
Is a lens hood really necessary?

An efficient lens hood will avoid flare in some situations, but unless it is one that is designed for a particular lens and shields it very closely it is not likely to be much help, particularly with modern coated lenses, as these are quite flareproof in any case. The best type of lens hood is the compendium type which professionals use since it can be adjusted to shade the lens to a very fine degree.

■
Are plastic filters as good as glass ones?

In optical terms they are perfectly satisfactory for general purposes but they are more vulnerable to abrasion. Certain filters – polarizing filters, for example – are of better quality in glass. It is also possible to obtain glass filters with coated surfaces which have better transmission and less risk of flare. A good compromise is to choose glass for those filters which are used most frequently, such as 81A, UV, and polarizing filters, and plastic for those used only occasionally.

■
What is a filter system?

This is simply a method of using mainly square plastic filters that fit into a common holder which can be adapted to fit a wide variety of lens mounts. It has the advantage of relatively low cost and avoids the necessity of your having to buy a separate filter for every different size of lens you acquire, as used to be the case with circular glass filters. Some systems such as the Cokin contain a very wide variety of both correction and effects filters, all of which can be integrated.

The integrated Cokin system uses a holder to enable easy and rapid changing of filters.

■■
What happens to the f-numbers when a fish-eye attachment is used on the front of a lens?

They are not affected, but it is advisable to use a small aperture to obtain the best definition.

■■■
What is a CC filter?

This is a colour correction filter. It is available in both primary and complementary colours in a wide range of strengths, and is usually made of gelatin or acetate.

■■
Can a polarizing filter cause underexposure?

If the metering system of your camera incorporates a beam splitter, you may get inaccurate exposure when using a polarizer. A *circular* polarizer will eliminate the problem, and is compatible with the metering systems of all SLR cameras.

Flash-guns

■
How is a guide number used to calculate flash exposure?

Divide the distance between the flash and the subject into the guide number; this gives you the aperture you should use. Remember to check whether the guide number is expressed in feet or metres.

Pentax 6 × 7; 150 mm lens;
f16 with studio flash;
Ektachrome 64.

■
What is dedicated flash?

It is a flash-gun with computerized exposure control that can be linked to the TTL metering system of a camera.

■
What do the guide numbers on an electronic flash-gun signify and why are they not the same on different units?

Guide numbers provide a method of calculating flash exposures and are consequently dependent upon the power of a particular flash-gun.

■■
With flash, how do I work out the exposure when using ISO 200 film for instance?

Most flash-guns are supplied with a guide number which is indicated in either feet or metres and relates to a specific film speed. If, for instance, the flash-gun has a guide number of 80 feet for ISO 200 film, then you simply divide the distance from the flash-gun to the subject into the guide number, and the result is the aperture for the correct exposure; at 10 feet, for example, it would be f8. If the film you are using is faster or slower than that indicated on the guide number, then you have to adjust the aperture accordingly; with an ISO 50 film, for example, you must open up one stop to f5.6, and with a faster film of ISO 200 you must set the aperture to f11.

■■
What is ring flash?

It is a flash tube formed in the shape of a circle which is designed to fit over the camera lens so that it can be used at very close focusing distances. It will also provide a virtually shadowless light.

Ring flash is particularly useful in close-up and macro photography.

■■
How can I operate two or more flash-guns at the same time?

It is possible to buy a two-way sync lead connector which enables the lead from the camera to be split and connected to two flash-guns. Alternatively, one gun can be connected to the camera in the normal way and one or more other guns fired simultaneously by means of a slave cell plugged into the sync lead socket.

■■■
What is meant by open flash?

Open flash is when you hold the shutter open on a time exposure and fire the flash-gun manually. It enables you to give a series of flashes on the same piece of film, either to build up a cumulative exposure or to illuminate a large area sectionally, or for a pseudo-strobe effect.

Lighting

Indoor lighting
Shooting in low light
Shooting in sunlight
Shooting in bad weather

Indoor lighting

■
What is 'hard' and 'soft' lighting?

'Hard' lighting creates a wide brightness range in the subject and casts dense shadows with well-defined edges; 'soft' lighting produces a low brightness range and the shadows are weak with soft or undefined edges.

■
How can I achieve a 'halo' effect round the model's head in a portrait?

You must literally 'hide' a light immediately behind the model's head, aimed towards the camera. This must obviously be a small lamp or reflector and it is easiest if it is positioned some distance behind the model.

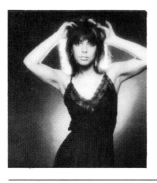

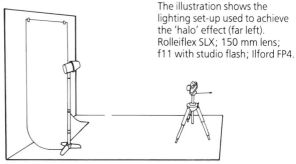

The illustration shows the lighting set-up used to achieve the 'halo' effect (far left). Rolleiflex SLX; 150 mm lens; f11 with studio flash; Ilford FP4.

■■
How is a silhouette effect created in a portrait shot?

The most important thing is to illuminate a white background as brightly and evenly as possible, and also to ensure that the minimum of light spills on to the model (barn doors or black-card screens can be used to ensure this). The exposure should be calculated so that the background is recorded as white and there is no detail in the model.

In a typical lighting set-up necessary to create a silhouette, two lamps are directed on a white background positioned behind the model.

■■
What is the best way of lighting a full-length portrait?

As a general rule, a fairly large soft source is best, such as that provided by an umbrella reflector or a diffusion screen. If a small hard source like a direct flash is used, it will be impossible to light a full-length figure evenly unless it is a considerable distance away. In this case the effect will create excessively high contrast unless the light is used frontally, and then the effect will be too flat with little modelling.

■■
What is the main purpose of rim lighting in a portrait?

It is an effective way of creating a degree of separation between model and background and the highlights it creates can give a picture a little sparkle.

■■■
How can I balance exterior and interior light levels?

The simplest way is to use flash as it is so brief that it can be used independently of the camera's shutter speed and the colour quality will match the daylight. You must first establish the exposure required for the exterior scene – say 1/125 at f8 – you can then position the flash-gun so that an aperture of f8 will give a slightly under-exposed result of perhaps half a stop. This will give a more natural effect and so it will be best to diffuse or bounce the flash for a softer light. If it is not convenient to adjust the position of the flash-gun independently of the camera position then you will have to calculate the correct aperture at its established distance, set this on the camera, and then reset the shutter speed to maintain the same exposure for the exterior.

Nikon F3; 75 mm lens; 1/125 at f8; Ektachrome 64.

■■
I find it impossible to get really dramatic lighting with strong shadows in my home studio. What can I do about this?

If you are working in a relatively small space with light-toned decor then there will be a considerable amount of stray light reflected around indiscriminately, reducing the contrast. The solution is either to hang the walls with dark drapes or to use 'black' reflectors around the model; one or two large pieces of hardboard or foam polystyrene with one side painted black and the other white can be used for this purpose and also to double as a conventional reflector.

In this candid close-up portrait, a black reflector was placed behind and to the side of the model to absorb any stray light. Nikon F2; 150 mm lens; f11 with studio flash; Ilford FP4.

■■
What is a typical lighting set-up for portrait photography?

The set-up which is used in the majority of conventional portraits is a soft key light to create the basic modelling (an umbrella reflector or a diffuser such as a window-light); a reflector to add light to the shadows; a spotlight or a light fitted with a snoot on a boom stand to create high-lights on the model's hair or to form a rim light around the face; and a third light to illuminate the background.

■■
What is the inverse square law in relation to lighting?

This states that the intensity of a light source diminishes in inverse proportion to the square of its distance from the subject, i.e. at twice the distance it will be a half squared, one-quarter of the brightness.

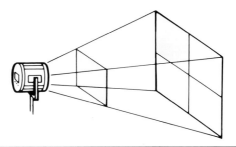

The illumination from a light source diminishes with distance. At twice the distance, the illumination will be four times less.

■■
What is a fill-in light?

It is a light used solely to reduce the density of the shadows in a subject.

■■■
Food shots and still-lives in advertisements often have a very distinctive lighting quality, soft but quite strong. How is this achieved?

This is often done by lighting the subject from almost immediately overhead with a large diffused source such as a fish fryer or a swimming pool. This is usually most effective when the light source covers an area as large as or larger than the subject.

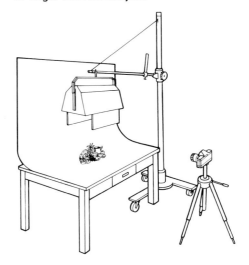

A swimming pool light is particularly effective for illuminating a still-life shot.

■
Can I mix daylight and electric lights when taking pictures indoors?

If you do this, you will find that either the area lit by daylight appears blue on film, or the area lit by electric light comes out yellow. Unless you are using black-and-white film, it is best to avoid combining light sources in this way. Flash is the same colour as daylight, so you can mix and match these two light sources without problems.

■
What sort of space is needed for a home studio?

A quite small space can be used for head-and-shoulders portraits: about 13 × 16 ft (4 × 5 m) will allow a suitable working distance from the model as well as adequate space between model and background and enough width for lights to be positioned. Remember that the camera can be positioned in an open doorway. For full-length shots you will need substantially more space: about 20 feet (6 metres) in length with a standard lens, and enough separation between model and background, and at least 16 feet (5 metres) in width so that there is room for a full-width roll of background paper and lighting stands.

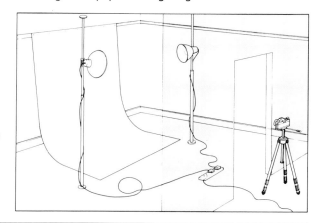

In a home studio where space is limited, sprung 'Vendor' poles fixed between floor and ceiling can be used to support lights and reflectors. The camera can be positioned in an open doorway.

■
What is meant by a key light?

This refers to the main light of a set-up, the one which creates the basic modelling and the strongest shadows.

■■
What is meant by a catchlight?

This is a term used to describe the small highlights created in the subject's eyes in a portrait. The presence of these highlights tends to add life and sparkle to the picture, and some portrait photographers employ a tiny spotlight near the camera to produce this effect when the key light alone does not create them.

■■■
When setting up indoor lighting arrangements I am troubled constantly by multiple shadows. How can I get rid of them?

In normal circumstances there should be a single predominant light (the key light), which is intended to create the shadows. Additional lights should only be used either to lighten the shadows created by the key light or to add highlights; the way to prevent these lights creating shadows is to adjust their brightness and direction very carefully. A light chosen to create highlights, such as a rim light, should be fitted with say a snoot so that it does not spill beyond the area requiring illumination. A fill-in light should be soft so that it cannot create noticeable shadows, or a reflector used. Multiple shadows are also caused by insufficient distance between subject and background.

■■■
What is the best way of simulating sunlight in the studio?

One method is to use a hard light such as a spotlight or an undiffused flash as a key light. Direct it from a fairly high position so that it casts a nose shadow which is at an angle compatible with that from the sun at about mid-afternoon. An alternative method is to use a very soft diffused frontal light and to backlight or rim light the subject with a quite hard light from a high position.

■■■
Is daylight indoors only suitable for black-and-white pictures?

No, it can be equally effective with colour film although you may have to use a faster film than normal and take more care over controlling the contrast. In some circumstances you may also find it necessary to use a warm filter such as an 81A as indirect diffused daylight can create a slightly cool colour quality.

Olympus OM1; 28 mm lens; 1/60 at f5.6; Ektachrome 64.

Pentax 6 × 7; 105 mm lens; 1/60 at f4; Ektachrome 200.

■■
**What is meant by
high-key and low-key
lighting?**

High-key lighting is virtually shadowless so that when it is applied to a light-toned subject the resulting image consists primarily of pale tones and/or colours. Low-key lighting creates large areas of shadows or dark tones with only a few areas of highlight.

■■
**How can I light a subject
to produce a low-key
effect?**

The essence of low-key lighting is to ensure that it creates tones that are predominantly at the darker end of the grey scale with only a few small areas of highlight. This is usually most effectively achieved by back or rim lighting, and you must also ensure that the subject is either essentially dark toned or contains no strong contrasts. A low-contrast subject that is light in tone can be lit to create a low-key image but it is not possible with one that contains a mixture of dark and light areas.

Pentax 6 × 7; 150 mm lens;
f11 with studio flash; Ilford FP4.

■■ What is the principle of high-key lighting?

You must first have a potentially high-key subject, i.e. one that contains at the most only small areas and details that are darker than mid-grey. The lighting should be arranged so that it is virtually shadowless; a very soft, diffused source directed from close to the camera is often the best solution for subjects like portraits, or possibly directly overhead for a still-life. You may also need to use reflectors or additional lighting to remove any slight shadows that may be created by the key light. A degree of over-exposure will help with black-and-white and colour negatives in particular, although too much exposure with colour transparency film will result in loss of detail.

Nikon F2; 20 mm lens; f16 with studio flash; Kodak Tri-X.

■■ Can natural daylight be used successfully in interior photography?

It can be very effective indeed and is widely used by professional photographers for a variety of subjects ranging from still-life to nude shots. The main problem is that of controlling the direction and quality of the light and since the source itself – the window or skylight – cannot be moved, it is necessary to alter the position of the camera and subject in relation to the window in order to vary the angle and direction of the light; if you want to have a particular background colour or tone this will also have to be movable. The quality of the light can be controlled by the use of a diffuser or even a net curtain over the window and by positioning one or two large white reflectors (made of white card, painted hardboard, or foam polystyrene) so that they reflect light back into the shadows to control the contrast and effect of the lighting. Because the light will be at an appreciably lower brightness level than when shooting outdoors you may need to consider using faster film and/or a tripod to enable longer exposures to be given.

Shooting in low light

■■
Are there any special problems with long exposures?

You must make sure that the camera is firmly supported and does not vibrate when the exposure is made, either by using a cable release or the self-timer mechanism. With an SLR it can be an advantage to use the mirror lock if the camera has one, and you should not forget to allow for the effect of reciprocity failure. It will also help to bracket exposures in most circumstances.

■■
What is a night lens?

It is a lens with a very wide maximum aperture (usually f1.2), which makes it ideal for low light levels. It is designed in such a way that flare from light sources is minimized.

Nikon F2; 24 mm lens; 1/4 at f5.6; Ektachrome 200.

■■
I do a certain amount of indoor architectural photography and some of my shots have an unpleasant green cast. What causes this and how can I avoid it?

This is caused by fluorescent lighting which while appearing white to the eye will create a green cast on daylight film. It can be corrected to a degree by the use of colour correction filters; a CC30 or CC40 Magenta is probably the right choice, but the effect varies according to the type of tube and it is advisable to test the lighting if possible, using your normal film. You must remember, however, that any daylight present in the picture will record with the magenta cast and the only solution to this is either to exclude the daylight or to cover the fluorescent lights with sheets of magenta-tinted acetate instead of placing the filtration over the camera lens.

■■
Can daylight fluorescent tubes be mixed with daylight in colour shots?

No. Although they appear similar, fluorescent tubes create a green cast on daylight film and the correction filters which have to be used will produce a magenta cast where the daylight predominates.

■■■
Will the exposure meter on my automatic camera work normally in low light?

All meters work best in normal light levels: shutter speeds of half a second or faster. Film loses sensitivity in dim light, and at shutter speeds of a second or longer meters indicate settings which will lead to under-exposure. To get correct exposure, set the controls manually, allowing for this loss of film speed. Film manufacturers publish the compensation needed, but as a rule of thumb, open the lens by half a stop when the indicated exposure is one second, by one stop for 10 seconds, and by two stops for a minute.

■■■
What special points should I take into consideration when taking photographs in twilight or moonlight?

The main problem is in the calculation of exposure since scenes of this type can have both a high contrast and an abnormal tonal range with large areas of dark tones. The former can cause under-exposure and loss of detail in the shadows, and the latter can cause over-exposure which will destroy the effect and mood of the image. It is often effective to calculate the exposure by taking an average reading or a close-up reading from an important detail, but in any event it is advisable to bracket the exposures quite widely. Since you will often need to give quite long exposures you must also allow for reciprocity failure.

Nikon F3; 150 mm lens; 5 at f8; Ektachrome 200.

Nikon F3; 400 mm lens; 1 at f5.6; Kodachrome 64.

■
What does the term 'available light' cover?

It normally means making use of existing light without any supplementary lighting and as a rule implies a relatively low level of brightness such as domestic room lighting or street lighting at night.

This shot of the Paris Metro was taken using the artificial lighting as the only source of illumination.
Nikon F; 50 mm lens; 1/30 at f2; Kodak Tri-X.

■■
What is the best way of shooting by candlelight?

The first consideration is of course the low brightness level. A fast film of, say, ISO 1000/31° uprated by 1 or even 2 stops will be necessary if shutter speeds longer than about 1/15–1/30 sec are to be avoided. Tungsten film is the best choice for colour shots, but even so there will be a warm colour cast, although this can contribute to the mood. If the candlelight is to be the sole illumination then the shot must be framed tightly as only the nearest parts of the subject will record. It can be effective to use a small amount of supplementary lighting to illuminate some of the shadow details but if the candlelight effect is to be retained it must be kept at a lower level or restricted to rim or backlighting.

■■
Some pictures I have taken of street scenes after dark are very contrasty and the parts that are illuminated by street lights are completely burnt out. How can I control the contrast?

One way to do this is by cheating slightly and taking your pictures before it is completely dark so that the remaining daylight reveals some detail in the areas not lit by the street lighting; this will enable you to give less exposure and avoid over-exposing the highlights. Alternatively, you must frame the pictures quite tightly so that only details and objects quite close to the illumination are included in the picture.

■■
How should I calculate the exposure when shooting against the light?

The best and most precise method is to take a close-up reading from a mid-tone in the most important area of the subject. Alternatively, you can increase the exposure indicated by a normal reading by between 1 and 2 stops. It is more difficult to make a precise calculation by this method since the increase will depend on a number of factors such as the reflective qualities of the surroundings and the distance between the camera and subject, and even the way the picture is framed and the angle of the backlight. Other possible methods include the use of an incident light reading, which can be effective with subjects like portraits, or by taking an average from the lightest and darkest tones in the scene, which can often be useful for distant shots and when the contrast is particularly high.

■■■
What are the particular problems of shooting pictures at a rock concert?

Nikon F3; 24 mm lens; 1/125 at f2.8; Ektachrome 200; colour original.

The main problem is that the spot lighting used for this type of event produces both very high contrast and uneven and constantly changing levels of illumination; consequently, exposure calculation can tend to be rather hit and miss. One method which should produce an acceptable result is to scan the field of view with the meter, avoiding any light sources, and note the extremes of exposure indicated and set the exposure between them. If you are shooting a complete roll or more it would be worth while making a clip test especially as you will probably be uprating the film in any case.

■
What is the best way to calculate exposure for a sunset?

Nikon F3; 75 mm lens; 1/125 at f11 (left), f8 (centre), f5.6 (right); Kodachrome 64.

So much depends on the nature of the sunset, for instance whether the sun is included in the picture area. However, a useful ploy in most cases is to take a reading from the area of sky immediately above the camera. Whatever method is used, a sunset is one subject where it is advisable to bracket exposures quite widely since both the quality and the effect will vary considerably and are difficult to predict with any degree of accuracy.

■■
What is the best way to photograph fireworks?

To photograph fireworks from a distance, for example at a public display, it is best to use a tripod-mounted camera and an exposure of several seconds to allow light trails to form and a number of effects to combine (a multiple exposure can often be effective). A long-focus lens is an advantage for such shots as it enables tight framing and avoids large areas of blank film. Closer shots involving people can often work well when flash is used to illuminate the figures, combined with a long shutter speed of perhaps a half or even one second or more to record the firework effects.

■■
What is the best way to photograph street illuminations?

It is often best to take pictures of this kind at dusk rather than when it is completely dark; this will enable you to retain some detail in the surroundings without over-exposing the illuminations themselves. You will get more impact from the pictures if you frame quite tightly, and a long-focus lens will often allow you to juxtapose lights on different planes to create a more dramatic effect. The possibilities of reflections should also be considered – in shop windows or wet streets, for instance – as these can help to produce a more interesting and even abstract quality in a picture.

■■
Is it best to use tungsten film when taking colour shots of a rock concert?

The colour quality of the lighting at such venues is so variable and unpredictable that it usually does not matter whether you use tungsten or daylight film.

▪▪
What can be done to brighten shots taken on dull days?

If you are taking a picture like a portrait, for instance, where you can control the subject directly, you can introduce bright colours – say a red hat – to create a colour contrast, or with a black-and-white shot you can include very light-toned objects. With a landscape picture, the effect lies in the choice of viewpoint and the way the picture is framed, by including very light or dark or brightly coloured objects in the foreground, for example, to increase the contrast of the image.

The brightly coloured boat in the foreground has counteracted the effect of the dull light by increasing the contrast of the image.
Nikon F3; 75 mm lens; 1/125 at f5.6; Ektachrome 64.

▪▪
What effect will street lighting have when shooting in colour?

This will vary according to the street lighting. There are essentially four main types: tungsten lighting will create an orange cast on daylight film but will be fairly neutral on artificial light film; most fluorescent light will create a green cast on either type unless correction filters are used; mercury vapour lights will create a green-blue cast on either film type; and sodium vapour lamps will create an orange-yellow cast with both types.

Shooting with daylight film has produced the orange cast in this picture of street lighting.
Nikon F; 50 mm lens; 1/30 at f2; Ektachrome 200.

Shooting in sunlight

■
Why is it said to be best to keep the sun behind you when taking pictures, and is this true?

Keeping the sun behind you will usually produce an acceptable result and it will be relatively simple to calculate the correct exposure. However, once you have gained a little experience and have become aware of the effect and quality of light, you will produce more interesting and often better pictures by choosing the lighting angle according to particular circumstances rather than by following a rigid rule.

■■
I often find when shooting into the light that my lens hood does not prevent flare. Is there anything else I can do?

This often happens when the light source is close to the edge of the picture or is included in it. In the case of the former you can often use your hand to shield the light from the lens or you can buy an accessory like a single barn door on an adjustable arm to serve the same purpose; however, this precise type of shading can only be done with through-the-lens viewing.

Shooting from an area of shade has hidden the camera from the sun, thus avoiding flare.
Nikon F; 24 mm lens; 1/125 at f5.6; Ilford FP4.

Can filters be used to improve shots taken against the light?

In some circumstances a polarizing filter can reduce glare caused by reflective surfaces. A warm filter such as an 81A can offset the blue cast sometimes created by these conditions and a graduated filter can often prevent sky tones from becoming over-exposed and bleached out.

Why is sunlight warmer in colour at evening than during the day?

Because at evening the light rays are at a more acute angle, which means that they have to pass through a greater volume of the atmosphere and so more of the blue wavelengths of light are absorbed.

What is meant by cross lighting?

This is a term used to describe a fairly hard source of light which is directed at the subject from an angle of about 90° to the camera position.

The long, defined shadows and strong shapes have been produced by shooting with the sun to one side of the camera. Nikon F3; 150 mm lens; 1/250 at f5.6; Ilford FP4.

What does the term contre-jour mean?

It means shooting towards the sun or other light source.

Shooting towards the sun has created pleasing lighting effects. Flare has been prevented by 'hiding' the sun behind a branch of a tree. Nikon F2; 24 mm lens; 1/250 at f5.6; Ilford FP4.

Shooting in bad weather

■■
Can I hope to take successful pictures even in bad weather?

Yes, indeed, you can, and bad weather has a number of positive advantages. The soft light of a cloudy day, for instance, can be more suitable for photographing very colourful subjects or those with an inherently high contrast. This type of lighting can also be more effective in creating pictures with mood and atmosphere than the lighting of a bright sunny day. In addition, conditions such as rain, snow, and fog can impart a quite unique quality to a picture to the point that almost any shot will have a degree of impact and will stand out.

■■
How can I take pictures in the rain so that the falling rain will show up in the picture?

There are two necessary considerations, one is to use a fast enough shutter speed to prevent the rain being too blurred to record on the film, and the other is to ensure that there is a quite bold tonal difference between the rain and the background. This can often be achieved by backlighting and it is possible to use a flash-gun to illuminate the rain in the foreground.

■■
How do atmospheric conditions like haze, fog, and cloud affect the quality of sunlight?

They will have a number of effects. Firstly, they will create a reduction in the light level so that more exposure or faster film will be necessary; secondly, they will reduce the density and definition of the shadows cast by the sun which in turn will produce a reduction in the brightness range or the contrast of the subject. When you are shooting in colour, conditions like this can also produce a blue cast on the film as a result of the presence of ultra-violet light.

Nikon F2; 150 mm lens; 1/60 at f5.6; Ilford FP4.

■■
Potentially pretty snow scenes often appear rather bland in the finished photograph. How can I avoid this?

Rolleiflex SLX; 150 mm lens; 1/125 at f8; Ektachrome 64.

In sunlight it is often possible to create a more pleasing and textured effect by shooting into the light rather than with the sun behind you. It is also necessary to find a bold tonal or colour contrast in some detail of the scene to create a centre of interest. For this reason you will often find that a tightly framed shot is more effective than a broad view. In addition it can be more effective when the snow only partially covers the landscape, leaving the darker uncovered edges of objects to create shapes and lines within the image.

Camera technique

Viewfinder and focusing

■
Why do I get more in my pictures than appears in the viewfinder?

A piece of tracing paper can be used inside the open camera as a makeshift screen.

Most cameras have a built-in safety factor so that the viewfinder shows less of the scene than is really being included on the film. This is usually more marked with a viewfinder camera than with an SLR. The best way of overcoming this problem is to take some test exposures, making a careful note of the extremities as indicated by the viewfinder, and compare them with the resulting photograph so that you know how much closer you can afford to move without fear of cutting into the picture. An alternative method is to place a piece of tracing paper inside the open camera with the lens open to act as a screen; in this way you will be able to make a direct comparison between the viewfinder image and the actual image.

■■
Is it possible to limit the depth of field?

Yes. Move as close as possible to your subject, select the widest aperture, and if possible use a long-focus lens.

■■
Where should I focus when taking a close-up portrait?

In most circumstances it is the eyes which are the most dominant part of a close-up portrait and this is where you should focus. With a three-quarter face shot focus somewhere near the bridge of the nose but make sure that at least the eye nearest to the camera is quite sharp.

Nikon F3; 150 mm lens; 1/125 at f8; Ilford FP4.

■■
How can I focus in poor light?

The best method is to find a highlight at the right distance or to place a torch in the picture area and focus on that.

■■
What is differential focusing?

This is a term used to describe the technique of isolating a subject from its surroundings by using very shallow depth of field so that although the subject itself is sharply focused everything else is thrown out of focus.

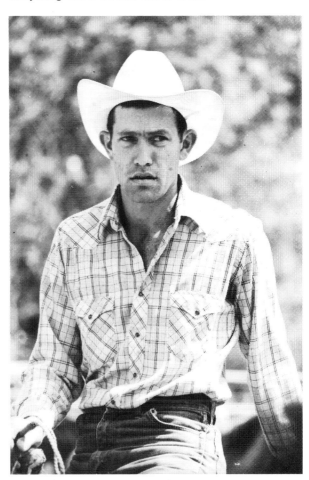

Nikon f2; 200 mm lens; 1/500 at f5.6; Ilford XP1.

■■■
What is meant by a lens with internal focusing?

With a normal lens, focusing is achieved by moving the entire group of lens components further from the film, resulting in the lens being physically extended. With an internal focusing lens individual elements within the lens barrel are moved to change the focus and the exterior of the lens remains the same.

■
Why are some viewfinder screens interchangeable, and does this have any advantages?

This is partly to satisfy individual preference and partly because certain types of screen are easier to focus on under specified conditions – some screens, for instance, incorporate a microprism or a split image to facilitate focusing in poor light.

■
I have problems estimating the focusing distance when using my compact camera. Is there an easy way?

Most cameras with a normal standard lens will fill the frame at about 9 feet (3 metres) with an adult figure and half the frame at 18 feet (6 metres); a half-length shot will be obtained at about 4½ feet (1.5 metres).

Subject at approx. 18 feet (6 metres).

Subject at approx. 9 feet (3 metres).

Subject at approx. 4½ feet (1.5 metres).

■■
I took some self-portraits in a mirror and although I was quite close to it I could not get the mirror frame and my image sharp. Why was this?

You probably did not allow for the fact that, in terms of focusing, the image in the mirror is actually twice the distance from the camera than the mirror itself. Moving closer to the mirror will actually make the problem worse since depth of field will be reduced. The best solution is to move the camera and yourself further away and use a small aperture.

■
Is automatic focusing foolproof?

No. With difficult subjects, you will have to focus manually or use the focus-lock control. Instant cameras which have ultrasonic autofocus cannot focus through glass, and may have difficulty with water, too. Compact cameras usually use an infra-red beam, and are fooled by light-absorbing subjects such as black fur. Autofocus SLR cameras do not work well in dim light, or with featureless subjects like plain walls.

■■
I find that I often do not get enough depth of field with my standard lens even at the smallest aperture. Would it be better to use a wide-angle lens and then enlarge the picture to get the same size image?

Unfortunately, this will not work. A wide-angle lens only has more depth of field in relation to a given viewpoint and its field of view. If you were to take three shots from the same viewpoint on a wide-angle, a standard, and a long-focus lens and then make prints to the same size of the same section of the subject, the depth of field would be the same.

■■
What is meant by zone focusing?

Nikon F; 24 mm lens; 1/125 at f8; Ilford FP4.

It is a method of focusing which utilizes the depth of field at a given aperture to enable a lens to be set so that sharp focus is obtained within a particular range of distance. This means that precise focusing is not necessary for moving subjects.

Aperture and depth of field

■
What are the various ways of altering depth of field?

There are essentially three ways. One is to vary the distance from the camera to the subject; this will increase the depth of field as the distance increases and will get less as you focus closer to the camera. Another way is to use a smaller aperture to increase the depth of field and a wider aperture to make it less. A third method is by the choice of lens; a wide-angle lens will effectively give greater depth of field and a telephoto or long-focus lens will give less. There are also ways of 'cheating' depth of field: the movements in a view camera can be used to increase depth of field, and for other types of camera you can buy a split focus attachment which is in effect half a close-up lens. This enables you to focus on close foreground details at the bottom of the frame, for instance, while still retaining sharp focus on distant details at the top of the picture.

The interesting effect of this shot was achieved by using a split focus attachment on the lens.
Nikon F2; 24 mm lens; 1/125 at f8; Ilford FP4.

■
What does 'stopping down' mean?

It simply means selecting a smaller aperture.

■■
What is the difference between depth of field and depth of focus?

Depth of field is the distance each side of the point at which the lens is focused that is also sharp; depth of focus is the distance the film plane can be moved and still retain sharp focus at a given point.

■■■
What is hyperfocal distance?

When the lens is set at infinity the nearest point to the camera which is still sharp is called the hyperfocal distance.

With the aperture set at f32 and the lens focused on infinity (far right), the depth of field extends from 100 feet (30 metres) to infinity. If the lens is re-focused to 100 feet (the hyperfocal distance), the depth of field will now extend from 50 feet (15 metres) to infinity (right).

■■■
How can hyperfocal distance be used?

By focusing at infinity you are in effect 'wasting' some of the depth of field, the area behind the point of focus. By focusing at the hyperfocal point infinity will still be sharp but you will gain additional sharpness in the area up to the hyperfocal distance.

Nikon F2; 24 mm lens; 1/125 at f8; Ilford XP1.

Understanding exposure

■
What does the term 'bracketing exposures' mean?

This is the technique of making additional exposures each side of the one calculated to be correct, usually either a half or one stop more and a half or one stop less. In unusual circumstances or in abnormal lighting conditions such as a sunset, however, it is sometimes advisable to bracket even more widely.

■
What happens when film is over-exposed?

It will produce a very dense negative in which the shadows will have excessive tone and the highlights will be almost solid with veiled details. Colour transparency film will be very thin and the colours pale and desaturated, highlight detail will be lost and shadows will record as a mid-tone.

This bizarre image is the result of an over-exposed negative.

■
I have an automatic camera. Does this mean that I cannot bracket my exposures?

No, but you must do it by altering the film speed dial on your camera. Setting the dial to a higher speed than the film in use will cause under-exposure and setting to a lower speed will cause over-exposure. With an ISO 100/21° film, for example, with the dial on ISO 50/18° you will get one stop more exposure, and with it set on ISO 200/24° you will get one stop less.

■■
What is the latitude of most ordinary films in terms of zones they can reproduce?

Negative films can usually record up to eight zones satisfactorily and colour transparency films six.

■■■
Is there more than one way of taking an exposure reading?

Yes, there are several ways. First of all you can use the incident light method, with the appropriate type of meter, which involves aiming the meter from the subject position towards the light; this method is ideal for subjects with an abnormal tonal range such as a black cat in a coal cellar. In addition to the conventional method of measuring the light reflected from the whole of the picture area and letting the meter calculate the average reading, you can also use the meter to measure the light from the brightest and darkest areas of a scene and then calculate the average yourself; this method is often effective with high-contrast subjects such as street scenes at night when you are unable to take a close-up reading from an average tone. Another method which is useful for subjects of abnormal tonal range such as high- or low-key images is the substitute technique, which involves placing an 18 per cent grey card in the same lighting conditions as the subject and taking a reading from that.

Nikon F3; 75 mm lens; 1/125 at f5.6; Ektachrome 64; colour original.

■
What happens when film is under-exposed?

Colour transparency film will be very dense with solid, blocked-up shadows and degraded highlights; slight under-exposure will create very rich colours and considerable under-exposure will make them dull and desaturated. Negative film will be very thin with no shadow detail and inadequate density in the highlight tones, and the image will also be of low contrast.

■
What is the best way of calculating the exposure from a backlit subject?

You can either take a close-up reading from the most important part of the subject or, alternatively, take an average from the lightest and darkest tones.

■
What is meant by the exposure latitude of a film?

It is a term which describes the amount of under- or over-exposure which can be given to a film while still producing an acceptable image.

■■
Does exposure latitude vary from film to film?

Yes, very much so. Colour transparency films have the least exposure latitude (usually less than half a stop), whereas colour negative films and black-and-white films can still produce an acceptable print with a stop or more over- or under-exposure. The chromogenic black-and-white films will produce a usable negative with several stops more or less than the correct exposure.

■■
The film speed dial on my camera goes only as far as ISO 400. Can I use ISO 1000 film?

Yes. Just take exposure meter readings as normal, with the camera set to ISO 400. Note the aperture recommended by the meter then set an aperture one and one-third stops smaller.

■■
Is there any way to save a film that has been wrongly exposed?

If the error is constant, such as setting the film speed dial to the wrong number so that the entire film is affected, it is possible to alter the speed during processing. Most colour transparency films can be down-rated by up to one stop and uprated by up to two stops.

■■■
What is an 18 per cent grey card and what is it used for?

It is quite simply a piece of card tinted to a precise shade of neutral grey which represents the average tone to which most exposure meters are calibrated. It is used for making substitute exposure readings with subjects of abnormal tonal range or for very precise exposure control.

■■■
Is there any way of varying the exposure of a picture other than by bracketing?

If you are prepared to shoot a complete roll on the same subject it is possible to make a clip test, which involves cutting off one or two frames from the end of the roll and processing this first; the exposure can then be adjusted for the balance of the roll by modifying the processing times. Most professional laboratories offer this service at a small extra cost.

∎∎∎
What is a high-low exposure reading?

This is a reading taken from both the lightest and darkest areas of the subject as the basis for a calculation or to estimate the contrast of the scene.

Nikon F; 50 mm lens; 1/250 at f8; Ektachrome 200.

Nikon F; 50 mm lens; 1/30 at f2; Ektachrome 200.

■
What is meant by the brightness range?

It is the difference between the lightest and darkest tones of a scene. When this exceeds 7 stops, which is the range the average negative film can record, it is called high contrast; when it is below 5 stops, it is called low contrast.

These two pictures are examples of the extremes of the brightness range: (top) the low brightness range, (bottom) the high brightness range.
Top Nikon F2; 105 mm lens; 1/60 at f5.6; Ilford FP4.
Bottom Nikon F2; 24 mm lens; 1/250 at f8; Ilford FP4.

■
Why does backlighting cause under-exposure?

This occurs because it creates bright highlights which will mislead the meter into believing that the scene is brighter than it really is.

■
In cases of doubt, is it best to err on the side of under-exposure or over-exposure?

As a general rule, it is best to err on the side of under-exposure with colour transparency film and on the side of over-exposure with negative films, since providing some detail is present in the highlight or shadow tones respectively it can always be brought out at the printing stage.

■
What is meant by 'opening up' in terms of exposure?

It simply means selecting a wider aperture.

■■
What are exposure values?

This is a system of relating a particular brightness level to cameras with a linked shutter and aperture so that when the exposure value has been set, all of the equivalent alternative aperture and shutter speeds are maintained as one or the other is altered. It is also used to indicate the sensitivity of a particular exposure meter.

■■■
What is the zone system?

This is a system of exposure calculation developed by Ansel Adams based on the principle that the brightness range of a subject is divided into ten zones, with zone 0 solid black and zone 9 pure white. Zone 5 is the average tone for which exposure meters are calibrated and is reproduced by the standard 18 per cent grey card. Each zone differs by one f-stop and by knowing how many zones a particular film or paper can reproduce you are able to calculate the exposure for a specific zone in order to obtain adequate detail in a certain area.

The grey scale of the zone system, divided into ten zones.

0 1 2 3 4 5 6 7 8 9

■■■
Is it all right to take TTL exposure readings through a filter or should the reading be taken before the filter is fitted?

With strong-coloured filters such as a deep red, for instance, it is best to take the reading without the filter and make an allowance for the filter factor since the colour sensitivity of the meter may not be evenly balanced. With graduated filters the reading should also be taken without the filter, but no allowance made as they are intended to make part of the image darker, and more exposure would negate the effect. With paler filters such as colour correction filters the TTL meter will be accurate with the filter in position.

Using filters

■
What is a graduated filter?

This is a filter of clear glass or plastic, of which half is toned, either neutral or coloured. The tinted area is graduated to create a smooth transition of tone. A graduated filter can be used to affect only part of the image, for example to make a sky darker while leaving the foreground without filtration.

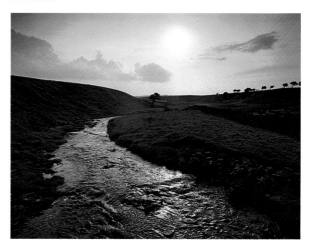

A tobacco graduated filter has added depth to the sky in this landscape shot.
Nikon F3; 24 mm lens; 1/125 at f8; Kodachrome 25; tobacco graduated filter.

■
How do you calculate the increased exposure required for a particular filter?

Filters are supplied with a filter factor which indicates the required increase in exposure; a factor of ×2, for example, needs 1 stop extra, ×3 needs 1½ stops more, ×4 needs 2 stops, and so on. You should not rely on a TTL meter when using strongly coloured filters since it may not be equally sensitive to all colours.

■■
Does it matter how many filters are used for a shot?

As even just one filter will have a detrimental effect on the sharpness and possibly the contrast of the image it is best to use as few filters as possible; there is no point, for example, in adding a red filter to a UV and it would be best to remove the UV first.

■■
What are neutral density filters used for?

They are used to reduce the brightness of the image without affecting the colour. They are available in a range of densities, allowing a reduction in brightness of, for example, 1 or 2 stops. Their main purpose is to enable a film or a combination of shutter speed and aperture to be brought within the range of a particular light level, for example to give a time exposure in bright light when the smallest aperture is still too large or when a fast film would be over-exposed even if the fastest shutter speed and smallest aperture were set.

■■
What are gelatin filters used for?

They are a relatively inexpensive type, available in a very wide range of colour correction and effects filters. They are used mostly for occasional specialist needs and where very fine degrees of colour control are needed. If handled carefully they can be used many times. It is possible to buy a special mount which holds the filter securely and flat in front of the lens.

■■
What filter is needed to convert daylight film for use in tungsten light?

An 80B, which is a blue tint. This will require an exposure increase of 1⅔ stops.

■■
What filter should I use for shooting artificial light film in daylight?

An 85B filter. This will require an additional exposure of ⅔ stop.

■■
Is it possible to judge the effect of colour filters with colour film by viewing a subject through them?

To a degree, yes, although the effect on the film tends to be greater than it appears visually.

■■
What is a fog filter used for?

A fog filter is a piece of glass or plastic with a slightly milky appearance which has the effect of reducing the contrast and colour saturation of the image. In distant shots this can create the impression of haze or fog, but when used with closer subjects it will produce pictures with a softer, more delicate quality. It can also be used to reduce the contrast when the brightness range of a subject is too great.

Olympus OM1; 50 mm lens; 1/125 at f8; Ektachrome 200; fog filter.

Nikon F2; 200 mm lens; 1/125 at f5.6; Ektachrome 64; fog filter.

■■
What is a colour balancing filter?

Colour film is manufactured for use with a light source of a particular colour temperature. If the light source is of a different temperature this will produce a colour cast. A colour balancing filter adjusts this difference in colour temperature, and brings the light source and the film into balance with each other. It is also called a colour correction filter.

■■
What is a colour contrast filter?

This is the name given to a filter which can be used with a black-and-white film to increase the contrast between different colours of similar brightness in the subject.

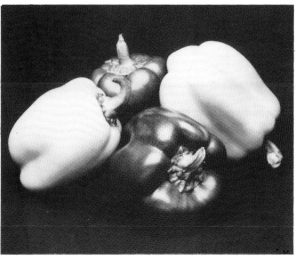

These two shots of red and green peppers on a blue background show the effect which can be achieved by a colour contrast filter; in the second shot (below), a red filter was used.
Above Pentax 6 × 7; 150 mm lens; f16 with studio flash; Ilford FP4. **Below** Pentax 6 × 7; 150 mm lens; f8 with studio flash; Ilford FP4; red filter.

■■
How does a polarizing filter work?

When light radiates from a source its wavelengths travel at all angles, but when it is polarized the wavelengths are made to oscillate in one plane only. Some light which is reflected from non-metallic surfaces is polarized. By setting a polarizing filter on the camera lens with its angle of polarization opposed to that of the reflected light, the polarized light is prevented from passing and some of the reflection is therefore eliminated.

A polarizing filter works like a screen of parallel slats. If it is aligned to the plane in which the polarized light is oscillating, there is no effect (far right), but when it is turned the polarized light is blocked (right).

■■
What can a green filter be used for in black-and-white pictures?

It can be very effective in creating a wider range of tones and textures in summer landscapes with green foliage and it can improve the quality of sunset shots. It will also create a more natural skin tone when shooting portraits in tungsten light.

The subtle differences in both the colour and the texture of the trees have been emphasized by the use of a green filter. Nikon F2; 150 mm lens; 1/125 at f8; Ilford XP1; green filter.

■■
What can a red filter be used for in black-and-white shots?

A red filter can reduce the effect of skin blemishes in portraits, give a darker tone to blue skies, show white clouds in more dramatic relief, and help to penetrate haze in distant shots. It is also an effective filter to use with black-and-white infra-red film.

■■
What can a blue filter be used for in black-and-white pictures?

It can emphasize the skin texture in character portraits and increase the effect of haze in distant shots.

Using close-up equipment

■■
**How can I ensure
sharpness in close-up
shots?**

There are three main things to consider. The first is the sharpness of the image on the viewing screen: focusing must be very precise with close-up subjects and in many instances you will find it easier to focus by moving the camera closer to and further from the subject rather than by adjusting the focusing ring. Secondly, depth of field is very shallow at close focusing distances so you should ensure that the subject is on a similar plane if possible and use a small aperture. The third thing is to make sure that there is no camera or subject movement at the moment of exposure as this will be accentuated by the magnified image. Always use a firm tripod and a cable release wherever possible – it can help to use the mirror lock on your camera if it has one as this will reduce the vibration. When you are shooting outdoor subjects such as flowers you must prevent movement which can be caused by a breeze; a cardboard shield placed near to the subject can help, and in some cases you can use a hidden piece of wire to support the flower stem.

In this shot, a tripod, cable release, and mirror lock were used, and an extension tube was fitted on the lens.
Nikon F3; 105 mm lens; 1/15 at f22; Ektachrome 64.

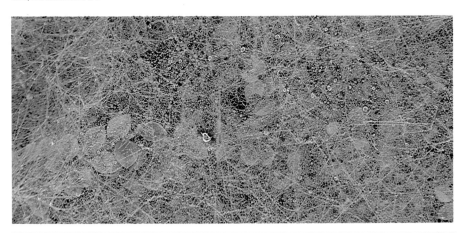

■■
**How do you calculate the
extra exposure for very
close-up pictures?**

If you have a camera with TTL metering it will make an allowance for the increased extension when a bellows unit or extension tubes are used. When a reading is taken with a separate meter it is necessary to increase the exposure indicated by the factor which is produced by dividing the square of the distance from the lens to the image by the square of the focal length of the lens. This means that a lens of 50 mm focal length extended to 80 mm would require an exposure increase of $80^2 \div 50^2 = 6400 \div 2500 = 2.56$; so if the basic exposure was one second the adjusted exposure would be approx. 2½ secs.

■■■
What is the best way to create realistic backgrounds with close-up shots of scale models?

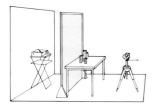

A typical set-up for a close-up shot of a scale model.

If you have a projector or can borrow one, you can create the effect most effectively by back projection. You will need a tracing-paper screen large enough to cover the necessary area of background and a piece of matt black fabric such as velvet to put over the screen. Place the screen close to the model, then set up the projector with a suitable slide behind the screen and size up and focus the image on to it. Switch off the projector and cover the screen with the fabric and light the model in the normal way. Then set up, frame, and focus the camera (mounted on a firm tripod). You can now make the exposure for the model, but remember that as you are going to make a double exposure it is vital that neither the camera nor the film be moved. The next step is to switch off the model lighting and switch on the projector, having removed the black cloth. With the room lights extinguished, and all daylight excluded, expose the projected image on to the same piece of film.

■■■
How do I get more depth of field in close-up shots?

The depth of field reduces dramatically at close focusing distances, so to obtain the maximum depth of field it is necessary to use the smallest aperture available. Some lenses will stop down to f32 or smaller and they can be an advantage. In addition, to minimize the problem you should choose your camera position and set up your subject in such a way that it is as far as possible on a similar plane. In some circumstances the movements of a view camera can be a help in gaining extra depth of field.

Nikon F2; 105 mm lens; 1/15 at f22; Ilford FP4.

■■■
When taking pictures of flowers growing in the wild I often find that when I stop down far enough to get the whole bloom sharp, the background also becomes too defined and distracting. Is there anything I can do?

The simplest solution is to use a small plain-coloured piece of card as a background, placed some distance behind the flower but in front of other plants or details. This will create a smooth, even tone and will not appear out of place if its tone and colour are chosen to complement the setting. An alternative could be to use backlighting or a shading device to subdue the background details.

Using wide-angle lenses

■

Is there more to a wide-angle lens than simply getting more of a scene in the picture?

Indeed there is. A wide-angle lens will have a considerable effect on the perspective of an image as well as the impression of depth and the relationship of the scale of different planes within a scene. This will in turn have a considerable influence on the composition and effect of a picture. In addition, some effects filters and attachments will have a more marked effect with a wide-angle lens, and the greater depth of field of such lenses can also be a considerable asset in some circumstances.

The use of a wide-angle lens has increased the impression of depth and emphasized the inherent pattern in the rows of bottles, creating an effective and interesting image.
Nikon F; 24 mm lens; 1/60 at f5.6; Kodak Tri-X.

■■

I used my wide-angle lens to take shots of a group of people and the pictures were very distorted. Is this because the lens is not suitable?

It is possible to use a wide-angle lens for this type of shot but you must be careful to use a viewpoint and to arrange the group so that everyone is on the same plane. It is also important to avoid having people too close to the corners of the frame and to shoot from a mid-point of the group both laterally and vertically – shooting from eye-level, for example, can cause people's legs to appear too short for their bodies.

■■
Has a wide-angle lens any particular use in portrait photography?

Yes, it can be very useful. Very wide-angle lenses can be used to create a degree of deliberate distortion for unusual and dramatic effects. An ordinary wide-angle lens can be an advantage for environmental portraits, in which the background or setting is important to the identity of the subject or to the mood or meaning of the picture; it will allow a quite close-up shot of the model and at the same time include a wide expanse of background.

■■■
When I take pictures with my wide-angle lens they have a different quality from those taken with my standard lens. Why is this?

Both the colour quality and the contrast can vary from lens to lens, particularly between different manufacturers. This can be a case for sticking to the same make of lens for an outfit to reduce this problem.

■■■
Is it difficult to use an extreme wide-angle lens such as an 18 mm, and what are its uses?

It is not difficult in the technical sense except that care must be taken in aligning the camera to avoid unwanted perspective effects. However, the range of subjects for which this type of lens can be used effectively is perhaps more limited and its effects can easily appear gimmicky if used too frequently. Apart from deliberate perspective effects its greatest asset is for shooting in very confined spaces and from restricted viewpoints.

This striking composition with its strong graphic sense is a good example of the possible effects which can be achieved with an extreme wide-angle lens.
Nikon F; 24 mm lens; 1/250 at f5.6; Ilford FP4.

Using telephoto lenses

■
Is a telephoto lens the best choice for taking candid shots?

Not necessarily, although it can be an advantage in some circumstances. A wide-angle lens can enable you to shoot at close quarters to a subject while giving the impression that the camera is not aimed at it, whereas with a telephoto lens it is quite obvious exactly where the camera is pointed.

■■
I have noticed that a long-focus lens is usually used for portraits. Why is this?

If you want to fill the frame with a subject's face, for instance, and you move the camera closer in order to do this, it will create an unpleasant perspective effect, but a long-focus lens will enable you to frame the picture more tightly from a more distant viewpoint.

■■
What are the main uses of an extreme long-focus lens?

The simple but effective juxtaposition of the sun and the crane in this image was achieved with a long-focus lens. Nikon F3; 400 mm lens; 1/250 at f8; Ektachrome 64.

It is usually used to provide a close-up image of a distant subject when a close viewpoint is either not possible or desirable, with wildlife pictures, for example, or in press photography where the allocated positions are often a long way from the subject. In such situations a 600 mm or 800 mm lens is considered a standard item, often with the addition of a converter to increase the effect still further. Another use is the creative effect which can be obtained by the unusual juxtapositions and apparent distortion of scale and perspective that a very long-focus lens can produce with objects on different planes, for example an enormous setting sun appearing to dwarf a foreground object.

■■
What are the best lighting conditions in which to obtain the optimum results from a telephoto lens?

Since in most cases the subject is at a considerable distance from the camera when a telephoto lens is used, it can be important with subjects like landscape, for example, that the light is quite crisp and clear. The effect of atmospheric haze will be accentuated with a telephoto lens and there will be a danger in some situations of insufficient contrast. With very long-focus lenses it can be a problem simply obtaining a really sharp image and bright light will allow the use of fast shutter speeds and smaller apertures, making this easier.

Above Nikon F3; 300 mm lens; 1/250 at f5.6; Ektachrome 64; polarizing filter. **Right** Nikon F2; 200 mm lens; 1/250 at f8; Ektachrome 64.

■■
Are there any particular problems connected with the use of a telephoto lens?

Limited depth of field and the greater risk of camera shake are the most obvious problems and a tripod will help in both cases, allowing a slower shutter speed and a smaller aperture to be used with confidence. Focusing can also be more difficult since such lenses often have much smaller maximum apertures than a standard lens. With lenses of very long focal length you may find that you will need a different type of focusing screen from the standard one that is fitted to make focusing easier. Some effects filters and attachments such as graduated filters are not effective with telephoto lenses.

■■
I have an SLR fitted with a screen with a split-image rangefinder but it does not seem to work when I use a long-focus lens. Is something wrong with it?

This type of screen is not really suitable for focusing when using either a long-focus lens or a small aperture. For this situation a plain Fresnel screen is the best choice.

Using Flash

■
What is the advantage of a flash-gun that has two flash tubes?

When you use bounce flash the effect, although softer and more pleasing than direct flash, can create excessive top light with shadows in the eyes. The small amount of direct flash which the second tube provides can offset this.

An electronic flash unit with two tubes.

Nikon F2; 105 mm lens; f11 with studio flash; Ilford FP4.

■■
I recently took some flash pictures at a party and they were very flat and muddy. What could have gone wrong? Was it the processing?

It is far more likely to be due to smoke in the atmosphere; with a camera-mounted flash-gun the smoke will reflect back the light and cause a fog-like effect. In these conditions it is best to use bounce flash or to hold the gun (or get someone else to hold it) well to one side of the camera.

■■
If I use two flash units together should I double the flash guide number?

Assuming that you are using the two flash-guns from the same position to increase the over-all output and they are the same power, the solution would be simply to set the aperture to one stop smaller than the guide number indicates for a single flash. If it were 110, for instance, and the flash-guns were 10 feet (3 metres) from the subject you should set the aperture to f16 instead of f11; if you were to double the guide number you would be under-exposing by one stop at f22.

■■
I recently took some photographs at a wedding but the shots of the cake showed no detail although I was using flash. Why do you think this was?

If you use a flash-gun mounted on the camera it will produce virtually no modelling within the subject, and if the subject itself has no tonal variation (as in the case of an all-white wedding cake) there will be no detail. The solution is either to use available light for the picture of the cake, or to hold the flash-gun above and to one side of the camera, or to bounce the light from the flash-gun from a white wall or ceiling.

■■
What setting should be used when taking outdoor pictures with fill-in flash?

You must first establish the aperture required to slightly under-expose the flash by about 1 to 2 stops and then set the corresponding shutter speed to give the correct exposure for the daylight as indicated by the meter.

■■
When taking outdoor pictures what can I do if the shutter speed required for the daylight is faster than that of the flash setting on the camera?

You must move the flash-gun closer to the subject so that you can use a smaller aperture and a correspondingly slower shutter speed.

■■■
Is it possible to achieve the effect of stroboscopic pictures with an ordinary flash-gun?

This can be done quite easily by using open flash in a darkened room. Frame and focus a suitable subject and then switch off the room lights and hold the camera shutter open on the bulb or time setting and fire the flash-gun as many times as you require while the subject changes position between flashes. If necessary, ask the subject to move in slow motion to allow the flash to re-cycle each time. For this technique you will also need a dark, or preferably black, background.

■■■
Can flash be used in close-up shots?

Yes, but the main problem is getting the flash in the right position as the camera can be in the way, which means that the flash is too far to one side, creating large shadows. There is a special flash unit called a ringflash which is designed to overcome this and also to produce a shadowless light. One solution with an ordinary flash is to use two small guns, one mounted each side of the lens.

■■
What is fill-in flash used for?

Fill-in flash is combined with the ambient light to reduce the lighting contrast by illuminating the shadows and reducing their density.

Rolleiflex SLX; 150 mm lens;
1/125 at f11 with fill-in flash;
Ektachrome 64.

■■
I understand that it is possible to use a flash-gun to alter the colour of the background in a picture. How is this done?

The technique is similar to that of fill-in flash where the light from the flash is combined with daylight. The effect is achieved by placing over the camera lens a colour filter of the tint that you want the background to be, and then putting a filter of the complementary colour and the same strength over the flash-gun. A 40 red filter, for example, placed on the camera would give the whole picture a red cast, but a 40 cyan filter on the flash which is illuminating the foreground details will neutralize the effect of the red filter in this area but leave the background tinted red.

■■
Are there any problems with a computer type flash-gun?

They are certainly not infallible. They work on a similar principle to an exposure meter by measuring the brightness of the light reflected from the subject, and can therefore be 'fooled' by subjects with an abnormal tonal range.

■■
How can 'red eye' be avoided in flash photography?

The 'red eye' effect is caused when the light of the flash-gun is reflected back from the retina. You can avoid this by making sure that the flash is not too close to the camera lens (it should be about a foot (30 cm) away to be safe); a flash bracket is a good way of doing this or the flash can simply be hand held. When you are using flash cubes or an accessory shoe flash-gun, try to ensure that the subject does not look directly at the camera.

This shot shows the 'red eye' effect caused by flash. Nikon F2; 105 mm; f11 with direct flash; Kodachrome 64.

■■
How should the additional exposure be estimated when using bounce flash?

Measure or estimate the distance from the flash-gun to the bounce surface and then to the subject, divide this into the guide number and then increase the exposure by one stop when using a white wall or ceiling in a light-toned room.

Rolleiflex SLX; 80 mm lens; f5.6 with bounce flash; Ektachrome 64.

■
Is a small flash-gun any use in photographing the interiors of buildings?

Not if they are of any size, unless the flash is used simply to illuminate foreground details with a longer exposure for the ambient light. Alternatively, a number of flashes can be given to sections of an interior with the shutter held open on a time exposure.

■
My flash pictures often appear rather cool. Why is this?

The colour temperature of many flash tubes when used undiffused is often slightly higher than that of the daylight temperature for which the film is balanced, and this creates a slight blue cast. This can be corrected with an 81A filter.

■■
Why should the fill-in flash be set to under-expose when taking outdoor pictures?

Because it is only intended to fill in the shadows and if the full exposure is given for the flash the result will appear very artificial.

■■
What does it mean that a flash-gun has so many joules?

Joules, or watt-seconds, are units of energy, but unlike guide-numbers, you cannot calculate aperture using a flash-gun's power rating in joules. Portable flash-guns are rated at 80 joules or less, and studio flash-guns at least 200 joules.

■■
Will an automatic flash still work when using bounce flash?

Only if the sensor remains aimed at the subject, as in the case of a swivel-head gun for instance.

■■■
What can I do if the aperture I need for the flash requires a faster shutter speed for the daylight than I am able to use with my focal plane shutter?

You must use a higher-powered flash-gun or move it nearer to the subject; this will enable you to use a smaller aperture and a slower shutter speed.

■■■
How is the flash exposure calculated for daylight shots?

In each case you must first establish the correct exposure for the daylight – for instance, 1/60 sec at f8. If you are using the flash to fill in the shadows you must then establish the correct exposure for the flash and set the aperture between one and two stops smaller, if necessary adjusting the shutter speed accordingly to compensate for the daylight exposure. If you are going to use the flash to balance a dark foreground with a brighter background then you should set the aperture perhaps just a half stop less than the correct exposure for the flash to avoid an unnatural effect. If the flash is being used to simulate sunlight on a dull day then you should reduce the daylight exposure between one and two stops and set the correct aperture for the flash exposure, ensuring that the flash-gun casts a shadow at an angle compatible with sunlight.

■■■
How can a flash-gun be used to improve lighting effects in daylight?

Rolleiflex SLX; 150mm lens; 1/125 at f8; Ektachrome 64.

There are essentially three ways. The first is to reduce the density of the shadows and thereby the contrast of the image; this is particularly useful when shooting in sunlight. The second is to create highlights and add sparkle to pictures on dull days. The third is to adjust the lighting balance, for example between a shaded foreground and a sunlit background.

Style and approach

Composition

■■
What is the best way of learning the art of composition?

Start to look at subjects inside a frame – you can even cut a rectangle in a piece of card and view through this. It is important to see the individual elements of a scene in relation to each other and within a defined border, and then to experiment with ways of altering that relationship by changing your viewpoint or altering the position of the frame to produce a more pleasing or effective arrangement.

■■
I have read that the best place for the subject is at the intersection of thirds. Is this true?

Like all rules it is based on basically sound advice and if followed will almost always produce a pleasing and balanced picture. However, it is never advisable to adhere to such rules slavishly and once you have recognized your own sense of what looks right then it is best to follow your instincts. Only in this way will you develop your own style and produce work with a more original and personal appeal.

Although this picture 'breaks' the rule of thirds, the result is none the less an effective image.
Nikon F2; 20 mm lens; 1/250 at f8; Ilford FP4.

**■■
What is meant by the
'elements' of a
composition?**

This can refer both to the individual objects in a picture such as a bottle, a glass, and a bunch of grapes in a still-life picture, for instance, and to their visual qualities such as shape, form, texture, colour, or even highlights or shadows. Basically, it is anything that can be used to help construct and compose a picture.

These two pictures are examples of shape (above) and texture (right).
Above Nikon F2; 105 mm lens; f11 with studio flash; Ilford FP4.
Right Nikon F2; 200 mm lens; 1/250 at f8; Ilford FP4.

**■■
Is there a simple way of
learning to judge a
subject in tonal values
and ignoring the colour?**

It can help to view a scene through a deep green filter since this will give a fairly accurate monochrome representation.

**■■
Is there any way of
practising composition?**

Experimenting with a few simple objects in a still-life arrangement is a very good way of learning to control the balance and effect of a picture. In outdoor situations you can try looking at subjects from a variety of viewpoints to see the effect this has on the composition.

**■■
What is the golden
mean?**

It is a term used in composition to indicate the way a rectangle should be divided to create a pleasing balance and to determine the point at which the centre of interest should be placed. It can be defined as the line which would make the rectangle into a square.

**■■
What is the rule of
thirds?**

This is a guideline used in composition which suggests the best point at which to place the centre of interest in an image. The rule states that this should be at the point of convergence between vertical and horizontal lines dividing the image into thirds.

■
Why do my pictures often look quite different from the way they appeared at the time I took them?

This is probably because you did not really look hard at what you were photographing. It is necessary to be fully aware of everything within the picture area, whereas when we look at things in normal circumstances our eyes tend to focus on interesting details and ignore irrelevant or distracting elements. The camera will record everything with equal emphasis and the result can sometimes be surprising.

■■
What makes a good photograph?

Irving Penn says a good photograph 'startles the eye', but at a more fundamental level you should have a clear idea of what you want the picture to look like at the time you shoot it, and train your eye to take a very objective and selective view of a potential subject.

■■
How can a long-focus lens be used to improve the composition of a picture?

In a variety of ways. It can help to exclude unwanted and distracting details from the picture by framing it more tightly, and it can also help to focus the attention on a particular aspect of a scene. The shallow depth of field of a long-focus lens can isolate a subject from its surroundings by throwing background details out of focus and creating emphasis. A long-focus lens can also be useful to manipulate perspective and create interesting and effective juxtapositions of objects within the picture area.

A long-focus lens has been used (above) to isolate small details in a subject and (right) to juxtapose planes and compress perspective.
Above Nikon F3; 150 mm lens; 1/125 at f5.6; Ektachrome 64.
Right Nikon F; 200 mm lens; 1/250 at f5.6; Ektachrome 64.

■■
What is the best way to develop a personal style?

This is largely a question of self-confidence. Following the various rules and even copying other people's pictures can be very helpful while you are learning the rudiments of technique, but once you have achieved a degree of competence you should have the confidence to follow your own instincts and if necessary reject the advice that books like this one give you. Have the courage to take chances, experiment, and do not always take 'safe' pictures.

What is meant by the decisive moment?

Its most significant meaning is in the context of composition rather than the more obvious one of a dramatic moment like a goal kick. The phrase was coined by Henri Cartier Bresson to describe the instinct that recognizes when a number of uncontrollable elements in a scene suddenly combine to create a unified and meaningful image. The explanation is in fact more complicated than the experience, and it is really just a feeling of things being 'right'.

What are the various ways of introducing mood into a shot?

Mood tends to be a quite subjective quality and people often disagree about what constitutes a 'moody' shot. As a general rule, however, if you want to create mood it is usually necessary to leave a little to the imagination. A picture that is sharp and clear and full of detail and information is not likely to have much atmosphere, so techniques that subdue these qualities can often contribute to the mood of the picture: lighting that creates large areas of shadow tones, for instance, or a high-key picture in which highlight tones are lost or subdued. Soft focus or differential focusing which suppresses the detail in an image can also be effective, and sometimes a colour cast such as the warm glow of late-afternoon sunlight or the blue quality of dusk can be effective in adding mood to a shot.

Mood has been introduced into this shot by the colour cast caused by the setting sun and by shooting against the light. Nikon F3; 35 mm lens; 1/125 at f8; Kodachrome 64.

Perspective

■
Why do the sides of tall buildings appear to converge when the camera is aimed upwards?

This happens because the base of the building is closer to the camera than the top and appears much larger in relation to the more distant dimensions.

Nikon F2; 20 mm lens; 1/250 at f11; Ilford XP1.

■
Why does a wide-angle lens distort perspective?

This is not actually the case, it simply allows us to see things that are much closer to the camera than we are used to as well as distant details, and draws our attention to the effect of perspective that is already there but which we do not normally notice.

Nikon F2; 20 mm lens; 1/125 at f8; Ilford FP4.

■
My landscape pictures often look flat and have no impression of distance. How can I overcome this?

The most effective way of increasing the impression of depth and distance in a picture is to include foreground details. This will accentuate the perspective effect and it will be given even more emphasis if a wide-angle lens is used.

■
What causes the compressed effect when long telephoto lenses are used?

Normal vision and standard lenses give a field of view of about 45° which in most circumstances enables us to see things quite close to us as well as distant objects, and we are used to things that are close appearing to be much larger than objects that are further away. However, when a picture of a very distant scene is taken through a long-focus lens we still gain the impression that it is close because of the magnification, and the fact that all the objects in the picture appear to be the right size seems odd. It is only because we have been presented with a small detail of a scene out of context and without close foreground details to relate it to that we are aware of a lack of perspective.

Nikon F2; 200 mm lens; 1/125 at f11; Ilford FP4.

■■
What is aerial perspective?

It is an effect usually created by atmospheric haze in which an impression of depth is produced as the tones in the scene become progressively lighter the further they are away.

Understanding colour

What is meant by a colour cast?

This is a term used to describe a bias towards a particular hue so that a neutral grey would show that tint. It is usually caused when the colour temperature of the light source is different from that for which the film is balanced.

How does exposure affect colour?

Under-exposure makes colours richer and stronger and tends to emphasize them, although a considerable degree of under-exposure will darken and degrade them. Over-exposure will make colours paler and softer – enough exposure would make a deep red record as pale pink.

A degree of under-exposure has added richness to the colours in this simple image.
Nikon F3; 75 mm lens; 1/125 at f5.6; Ektachrome 64.

Correct exposure in this shot of beach-huts has ensured evenly balanced colours.
Nikon F3; 35 mm lens; 1/125 at f8; Kodachrome 25.

The pale, soft colours, which add to the romantic effect, are the result of over-exposure.
Pentax 6 × 7; 150 mm lens; 1/125 at f4; Ektachrome 64.

What is meant by colour saturation?

This describes the purity of a particular hue. A fully saturated colour contains no white, grey, or other hues.

Are some colours more dominant than others?

Yes. The warm colours such as red, orange, and yellow do create more emphasis in a picture and are more assertive than the cooler hues like green and blue. Fully saturated colours are also more dominant than pastel hues or dark, subdued colours.

What is meant by a complementary colour?

It is the colour which is 'opposite' to a particular hue, and if combined with it will make it neutral. The complementary colour of red, for example, is a mixture of green and blue known as cyan. If you stare at a bright colour for a long time and then look at a white area you can often see the complementary colour.

■■
Can filters be used to emphasize colours in a picture?

A polarizing filter can often do this by eliminating surface reflections and glare and allowing the colours to record more strongly without actually altering them. In addition it is sometimes possible to use a colour correction filter of the same hue to emphasize a particular colour in the subject; however, this will affect the other colours in the scene.

The use of a polarizing filter has increased the colour saturation in this picture of an open-air market.
Nikon F3; 24 mm lens; 1/250 at f5.6; Ektachrome 64; polarizing filter.

■■
How can colour be used to control the mood of a picture?

Individual colours do have a 'mood value' of their own. The warm colours of the spectrum, like orange, red, and yellow, have a generally bright and cheerful quality, greens and blues a more restful and peaceful mood, and the more sombre tones of indigo and violet tend to produce a rather serious or foreboding quality. When any of these colours dominates the over-all colour quality of a picture it will tend to affect the mood.

■■■
Can filters be used to create a harmonious colour quality in a picture?

Only to a limited extent, since the presence of contrasting or discordant colours can only be eliminated by the choice of viewpoint and the way the picture is framed. However, a degree of harmony can sometimes be produced by using a filter to create or emphasize a colour cast like the bluish light of dusk, and this can help the colours in a scene to blend. A fog or pastel filter can also help to weaken and soften colours and make them more harmonious, as can a soft-focus attachment in some circumstances.

These two pictures have been taken with the use of a blue filter to emphasize the colour cast.
Right Nikon F2; 200 mm lens; 1/60 at f4; Ektachrome 200.
Far right Nikon F3; 70 mm lens; 1/125 at f4; Ektachrome 200.

Nature and wildlife photography

■

I would like to attempt some photography of birds but I only have a fixed lens camera. Would it be impossible?

Not impossible, but you will, of course, be restricted to fairly tame or captive creatures that you can approach quite closely, as otherwise you will simply not get a large enough image on the film with a standard lens. Waterfowl in an urban lake or pond would be feasible, and of course shots at a zoo. You might also consider the possibility of photographing wild birds in your garden with the aid of a long air release; this would enable you to set up your camera on a tripod aimed and focused at a point at which the birds are likely to settle – a titbit suspended from a branch, for example. Screen the camera behind some foliage, fit the release, and then retreat behind a suitable cover and wait for a subject to arrive.

Nikon F2; 105 mm lens; 1/125 at f5.6; Ilford FP4.

■■

How can I improve the effect when taking pictures of large, dull-coloured animals such as elephants?

This can be most effectively done by emphasizing the shape and texture of the animal and in this respect lighting can be a crucial element. Strong side light, for example, can be used to reveal the textural quality of the animal's hide and backlighting can emphasize shape. You should also look for ways in which the background can be used to create a bold tonal or colour contrast to add impact to the picture and emphasize the subject, and for this reason the choice of viewpoint is very important.

■■
Is it possible to exclude the cages from a shot when photographing animals at the zoo? How is this done?

You must place the lens as close to the wire as you can, use a wide aperture and if possible a long-focus lens. Provided your subject is focused at a reasonable distance from the wire, say 6 feet (2 metres) at least, it should be thrown so far out of focus to be invisible.

Nikon F2; 200 mm lens; 1/250 at f4; Ilford FP4.

■■
What shutter speed is necessary to freeze the movement of a flying bird?

A large bird with a fairly slow wing movement such as a seagull could be photographed using a relatively slow shutter speed of about 1/250 sec, providing the camera is panned. Small birds with very rapid wing action will need the fastest speed you can use to obtain a sharp image; some actions could in fact not be recorded sharply without high-speed flash equipment.

Nikon F2; 150 mm lens; 1/250 at f5.6; Ilford FP4.

Photographing people

■
Is eye-level the best position for the camera when taking a full-length portrait?

In most circumstances no, since particularly with a close viewpoint and a standard lens the perspective effect can easily create a foreshortened image in which the model's legs appear too short. Positioning the camera about level with the model's waist would be a better angle.

■■
What are the points to look for when taking group shots?

Since a group picture is usually intended primarily as a record of each individual it is vital that every person is visible; the group should be arranged with this in mind but also to create a pleasant composition. In addition, the lighting should be organized so that the relatively small areas of people's faces are not obscured by shadow, so a fairly soft frontal light is best. It is also important that at the moment of exposure everyone is facing towards, if not looking at, the camera and has a pleasing expression. This requires a quite assertive approach on the part of the photographer as he must be able to command attention, especially with a large group.

Nikon F2; 105 mm lens; 1/250 at f8; Ektachrome 64.

■■
How can I photograph my reflection in a mirror?

You can do this so that the camera is either included or excluded from the picture. If you choose to exclude it then you will have to position yourself and the camera so that you are both at an equal angle to a line at right-angles to the mirror's surface (see illustration).

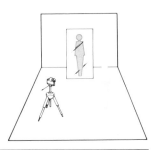

The illustration (far right) shows the set-up for photographing one's reflection in a mirror.
Right Rolleiflex SLX; 80 mm lens; 1/15 at f5.6; Ektachrome 64; bounce flash.

■■
I would like to try a self-portrait. What equipment do I need and how do I go about it?

You can take a self-portrait with almost any type of camera, but it would be easier with a camera that has a motorwind and possibly autofocus. There are essentially three ways to shoot a self-portrait. One is to photograph your reflection in a mirror. Another is to set up the camera on a tripod and pre-focus and frame the camera using some form of setting such as a chair that will enable you to adopt a pre-determined position; the exposure can be made by using the self-timer or delayed action shutter release. A third, and more satisfactory, method of making the exposure is to use a long air release. Be careful not to attempt too close a shot unless you have an autofocus camera as even a slight difference in your position and the point of focus will result in lack of sharpness. For this reason it is also best to use a small aperture when possible.

■■
What are the advantages of using a long air release for taking a self-portrait?

The use of a long air release enables you to make the exposure at a precise moment rather than leaving it to the self-timer, which can be inhibiting and make you self-conscious. You can hide the bulb of the release in your hand or even operate it with your foot.

Right Rolleiflex SLX; 80 mm lens; 1/30 at f5.6; Ektachrome 64; bounce flash. **Far right** long air release.

■■
How can I get people to relax for a portrait?

The best way is to be relaxed and confident yourself, and this means that you should be well prepared for a session with everything set up ready and checked. Make sure you are thoroughly familiar with your equipment so that you can devote your full attention to the subject. Mounting the camera on a tripod will enable you to communicate more directly with your model. Aim to carry on a normal conversation while you are working and allow the right expressions and poses to come naturally rather than by giving directions.

Nikon F3; 150 mm lens; 1/60 at f3.5; Ektachrome 200.

■
When I take close-up portraits the people often look slightly strange; what could be the reason?

This happens because you are using too close a viewpoint and the perspective is being accentuated – even at 4 or 5 feet (1.5 metres) from the subject there will be an enlargement of the nose, mouth, and chin in relation to the rest of the face. The solution is to use a more distant viewpoint and a long-focus lens or simply to enlarge the image and crop the picture.

■
What is the best way to pose someone for a head-and-shoulders portrait?

This will obviously depend to some extent on the desired effect and composition of the picture you want to take, but for a conventional arrangement it is best to seat your model so that he or she is just below the level of the camera; use a low-backed chair or a stool so it does not intrude into the picture area. It often looks more attractive and relaxed if the model is leaning slightly towards the camera; this can be achieved by seating the model the wrong way round on the chair so that the chair back is used as a support, or by letting him lean forward with an arm or elbow resting on one knee. Try to avoid the model's shoulders being presented square on to the camera: an angle of about 45° is usually satisfactory.

■
My holiday photographs always look very stiff and posed. How can I overcome this?

This is probably happening because you are making an occasion out of taking the photographs by interrupting what people are doing. It is far better to shoot while they are actually doing something or are preoccupied. If you have to arrange them into a group or make them stand in a special place for some reason, do not just ask them to smile at the camera, get them to react naturally by telling them a joke, for instance, or let them think you have taken the shot and then really shoot it when they have relaxed. Also try not to have people standing, as this almost always looks stiff, get them to sit, kneel, or even just lean, and try to find something for them to do with their hands.

■■
What is the best way of arranging a formal group?

If you can, it is best to avoid arranging the subjects in a single line as this often appears rather stiff, and it is difficult to fit the whole group comfortably within the frame. If it is unavoidable, however, the arrangement looks best if you set it up so that the line forms a slight semi-circle, with the people at each end slightly closer to the camera. Where possible, arrange people in a number of sub-groups according to height and arrange these in rows with the shortest at the front, so that the heads of the row behind appear between the heads of the row in front. Make use of any natural variations in height of the setting – steps or a slope, for example – otherwise you may need to use chairs. Where appropriate, with a sports team for instance, you can get the front row to kneel in order to include an additional row if there is a large number of people.

■■
I have noticed that professional portrait photographers often pose the model at an angle in the picture; how do they do that?

This is often done by just tilting the camera slightly so that it leans to one side, with the model sitting quite upright.

Rolleiflex SLX; 150 mm lens; 1/15 at f5.6; Kodak Tri-X.

■■
I have been asked to take the photographs at a friend's wedding, could you give me some hints?

If you are to be the official photographer and will be responsible for the formal groups it is vital to be well prepared and organized. Visit the scene of the ceremony and reception beforehand and establish some suitable locations for the main pictures with particular attention to backgrounds and lighting. High subject contrast is usually an inherent problem with wedding pictures and you should look for areas of open shade in the event of the day being sunny; if shade is not possible then you would be advised to consider using fill-in flash if the lighting is very contrasty. Make a list of the principal shots and where you intend to take them and work out a timetable so that you know where to be, and when. It is a good idea to enlist the help of someone like the best man or a principal guest to help organize the groups; these are most easily accomplished by starting with the bride and groom and gradually building up to the largest group. You will find a second camera or body a distinct advantage both for saving time in reloading and as an insurance against breakdowns. Try to arrange a quiet moment to take some relaxed shots of the bride and groom and find out if there are any special pictures they would like, for example of long-lost relatives. Do not forget to look out for those spontaneous and candid pictures that can often be the most pleasing. Finally, make sure that you present the proofs well and have an effective system of identifying prints and negatives to facilitate ordering of individual shots.

Shooting landscapes

■

Where is the best position for the horizon when taking a picture of a landscape?

It depends on the nature of the picture but as a general rule it is best if the horizon does not divide the picture area into two equal parts. If the foreground is of particular interest or if the sky is blank or uninteresting, then place the horizon somewhere between a third and a quarter of the way from the top of the picture; if the sky is particularly interesting or if you want to emphasize it, then place the horizon in a similar position at the base of the frame. Other factors such as the shape of the line will also be important, and you should let individual circumstances dictate the most effective position.

Right Nikon F3; 24 mm lens; 1/30 at f5.6; Ektachrome 64. **Far right** Nikon F3; 75 mm lens; 1/250 at f5.6; Ektachrome 64; polarizing filter.

■■

Do colours affect the impression of depth and distance in a landscape picture?

Yes. The warm colours (red in particular) tend to 'come forward' in the picture – a bold red detail in the foreground of a shot, for example, can often have an almost 3-D effect. Blues, on the other hand, appear to recede; this can be particularly evident with the effect known as aerial perspective in which haze creates both lighter and bluer tones in the distance because of the ultra-violet light.

Nikon F; 105 mm lens; 1/250 at f8; Ektachrome 64.

■■
What is the best way to calculate exposure for snowscapes?

The most reliable method is to take a close-up reading from a mid-tone in the subject but if this is not possible you can increase the reading taken from a light area in which you want to obtain highlight detail by 3 to 4 stops. If you have a hand meter you can also take an incident light reading.

■■
How can haze be exploited in a picture?

Haze can benefit a picture in terms of mood and can create an impression of depth by means of aerial perspective. This is the effect where the tonal quality of the planes in an image becomes progressively lighter the further they are from the camera. The effects of haze can be accentuated in black-and-white pictures with a deep blue filter, which can be further emphasized by a long-focus lens. In some cases a fog or pastel filter can create or exaggerate haze.

Nikon F2; 105 mm lens; 1/125 at f5.6; Ektachrome 64.

■■
I took some autumn scenes and the colours were rather disappointing. What could I do to improve them?

The rich autumn colours can be accentuated by the use of a warm colour correction filter such as an 81B or 81C. You may find that a polarizing filter will reduce some of the light reflected from the leaves and also increase the colour saturation.

Nikon F; 105 mm lens; 1/250 at f5.6; Ektachrome 64; 81C filter.

Still-life photography

■
Is studio lighting essential for still-life photography?

No, in fact daylight indoors can be particularly effective for such pictures. With the camera mounted on a tripod and a static subject, long exposures can be given and the brightness of the light is not an important consideration.

Pentax 6 × 7; 150 mm lens;
1/125 at f8; Ilford FP4.

■■
I want to photograph some glassware. What is the best way to light it?

In order that its translucent quality be revealed effectively it is best to place the glasses in front of a white background and to illuminate this evenly. You can than add just a little frontal lighting to create some highlights on the surface of the glass. This, combined with the use of pieces of carefully positioned black card, will reveal any texture or engravings.

■■■
What is a light tent used for?

This is a technique used for photographing highly reflective objects with curved surfaces such as silverware. The subject is surrounded completely with a 'tent' of white translucent fabric in which a small hole has been cut for the camera lens; the tent is then illuminated as evenly as possible from the outside.

■■■
Is there any way of subduing reflections when photographing silverware?

Professional dealers supply a dulling solution in an aerosol spray which can be applied to the objects and is easily removed afterwards. A similar effect can be achieved by painting the offending area with milk.

■■■
How do I take pictures through glass, of museum exhibits for example, without getting reflections from the glass?

First of all you should ensure that the surroundings are essentially much darker than the subject; if necessary erect black screens or drape dark fabrics around the working area, paying particular attention to light stands and tripods. Then arrange your lighting so that its reflections are not visible from the camera position; use a polarizing filter to eliminate any reflections which do remain.

■■■
I would like to try some food photography. Could you give me some general advice?

An effective food photograph depends primarily on wholesome, attractive ingredients so you should ensure that the items you use are of the highest quality and without flaws. Prepared dishes usually look best lightly cooked so that shape and texture are retained; a light application of glycerine or oil can be used to give an attractive sheen. As the elements of form, texture, and colour are vital to good food photography the lighting should be arranged with this in mind. The lighting should be kept quite simple – often a single large diffused source used quite directionally is enough, with reflectors to control the density of the shadows and small mirrors to create additional highlights. Image quality is also an important factor and a slow, fine-grained film or large format film is the best choice.

■■■
How can I take pictures of small objects on a pure white background with no shadows?

A simple method is to set up a large piece of plate glass or opal perspex to form a table top, with a piece of white card or paper on the floor below it. By lighting the card quite evenly with a light each side and shielding them to prevent spill you will create a light box, and providing that the frontal illumination of the subject is carefully balanced, the shadows it casts will be eliminated and the background will appear as pure white.

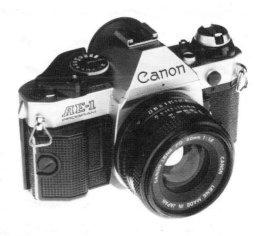

Pentax 6 × 7; 150 mm lens;
f16 with studio flash; Ilford FP4.

Sport and action photography

■
I only have a simple camera with a fastest shutter speed of 1/250 sec. Is this suitable for action pictures?

If you take a certain amount of care, this will be adequate to freeze the action of many fast-moving subjects. A controlled panning movement will ensure sharp pictures of most subjects that move across the camera. Where panning is not possible you can make the most of a relatively slow shutter speed by shooting at the peak of the action, i.e. when a subject momentarily slows, such as a high-jumper at the apex of his leap.

■
How are very close-up pictures taken of dramatic moments at sports meetings, for example?

These are often taken with the aid of a remote-controlled camera, usually with a motor wind and automatic exposure control. The camera is set up in a pre-determined position and fitted with a device that will allow it to be fired by remote control such as a radio signal. Professional sports photographers often set up a second camera in this way to cover an alternative viewpoint at an important event or when a particular viewpoint would be inaccessible.

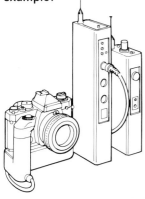

The use of a radio control (far left), where the receiver is attached to the camera and the transmitter is hand-held, makes it possible to capture dramatic high spots.
Left Nikon F3; 300 mm lens; 1/500 at f5.6; Ektachrome 200.

■■
Are there any particular ways of improving panning technique?

The main thing is to develop a smooth, even action which keeps the subject steady in the viewfinder. It will help if you develop a 'follow-through' action (like a tennis player, for instance) whereby you pick up the action well before the moment when you want to make the exposure and let the movement continue afterwards. This will enable you to develop an accurate pace.

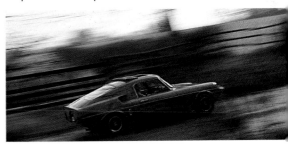

Nikon F; 105 mm lens; 1/30 at f11; Ektachrome 64.

■■
I find it very difficult to focus on moving subjects with my long-focus lens. Is there a knack?

It is difficult to follow focus by twisting the focusing ring as the subject moves with any lens, especially a long-focus lens where the amount of travel on the ring is much greater. It is possible, however, with a lot of practice, and some people find the squeeze-focus lens like the Novoflex easier in this respect. The safest method, though, and one that is widely used is to pre-focus at a spot where you estimate the optimum point of the action to be and simply wait until the subject arrives at this place. This is most satisfactory with predictable subjects like a track event but even with other actions like field games it can be used effectively.

■■
I would like to try some shots of a moving vehicle from another car. Are there any special points to watch?

First of all, never attempt to do this on a public highway. Ideally, the car you are shooting from should have a sun roof or at least allow you to shoot from the boot or tailgate; side windows are only suitable if the vehicles are side by side. Since you obviously want to create the impression of movement select the slowest possible shutter speed that you think you can hold steady: if the vehicles are on a smooth surface this could be as long as 1/15 sec, for instance. You will get more blur from the road and background if you shoot on a fairly wide-angle lens and include details close to the camera. This will mean, however, that the subject vehicle will have to follow quite closely; do not try this unless you and both drivers are happy that there is plenty of room to manoeuvre and brake.

Nikon F2; 35 mm lens; 1/30 at f16; Ektachrome 64.

■■■
I am interested in athletics and would like to take pictures of track events. What focal length of lens do I need and would a zoom be best?

It depends to some degree on your vantage point. If you are a spectator at a national event and do not have a special privileged seat then it is likely that you will need a lens with a quite long focal length of 400 mm or more; on the other hand, if it is a smaller, less formal event, or if you have a press pass which allows you a closer viewpoint, then a shorter lens such as a 200 mm would be more useful. A zoom lens can be an advantage in that you will be able to adjust the framing as the subject moves towards you, but this can be difficult to handle when you have to change focus as well.

Creating special effects

■■
What is the best way to shoot pictures of people against the background of a sunset and avoid a silhouette effect?

If the people are not positioned very much above the horizon, you can use a graduated filter to make the sky darker without affecting the lower half of the picture; this will enable you to give full exposure to the people. If they are positioned directly against the sky, you can use a flash-gun to illuminate them with the shutter speed selected to give the correct exposure for the sky at the aperture required for the flash exposure.

■■
How do I obtain a grainy or solid black or white background in black-and-white photography?

A grainy effect can only be created when there is tone present in an image, not with pure black or white. It can be most easily achieved by using a fast, coarse-grained film and enlarging the image considerably; the grain will affect the whole image and not just the background. A solid white or black background can be obtained by ensuring that it either reflects much more light than the subject to produce white, or much less to produce black; this can be done by adjusting the balance of the lighting and/or the use of white or black background papers or fabrics.

Right Nikon F2; 105 mm lens; 1/125 at f5.6; Ilford FP4.
Far right Nikon F2; 75 mm lens; f11 with studio flash; Ilford FP4.

■■
What are the various ways of creating soft-focus effects apart from using manufactured attachments?

One of the most effective ways and one that gives a quite different result from the manufactured devices is to smear a little clear petroleum jelly on to a filter or piece of glass such as a slide cover, leaving a clear spot in the centre. You can create swirls in the jelly which will produce a variety of highlight streaks and halos. White, black, or even tinted nylon mesh stretched over the lens with a small hole in the centre can also be effective (an old pair of ladies' tights is ideal), and spraying hair lacquer on to a piece of glass is another popular method. Breathing on to the lens can produce some interesting effects and if you do it on the inside the effect will last longer. A common method is to stretch clear plastic tape over a lens hood, leaving a spot in the centre; a similar effect can be obtained by placing a piece of plastic sheet over the lens. If you have a bellows attachment or extension tubes or can rig up a focusing mount with a cardboard tube, you can get some very pleasing effects with old box camera or magnifying-glass lenses.

One way of creating soft-focus effects is to stretch clear plastic tape over the front of the lens.

■■
**How can soft focus best
be used in a picture?**

It can often be used effectively to create mood by subduing details and creating a less 'real' image. It can also enhance the effects of back or rim lighting when it causes the highlights to create a soft glow around the subject, and in portrait and glamour photography a soft-focus effect can be used to flattering effect by minimizing skin texture and blemishes. In some circumstances it can produce a more harmonious colour quality by making colours softer and paler and helping them to blend.

■■■
**Is a special film required
in order to make a
silhouette?**

The main requirement for a silhouette picture is to have a high-contrast image which gives a pure black-and-white, so it is best to use a high-contrast film such as a Lith film or to under-expose and over-develop a normal film to increase the contrast.

Nikon F2; 150 mm lens; 1/250 at f8; Ilford FP4.

■■■
**What is meant by
painting with light?**

It is a technique used to illuminate large areas or to create a shadowless lighting on an object. It involves moving the light source progressively during a long exposure to cover the whole field of view.

■■■
**Is it possible to take
pictures in the dark using
infra-red film?**

Yes, this is possible if you use black-and-white infra-red film with say a flash-gun as the light source. The technique is to 'illuminate' the subject by placing an opaque infra-red transmitting filter, available from Kodak, over the flash.

■
Is it possible to get a soft-focus effect by just throwing the image out of focus?

No. The effect is quite different, because with a soft-focus attachment there is a central core of sharpness which is surrounded by the softer image, and this does not happen if the image is simply out of focus. Under some circumstances, however, an image which is very out of focus can look effective as an abstract picture.

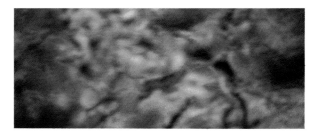

In this shot, the effect has been created by focusing the lens at a point midway between the foreground and background objects.
Nikon F; 105 mm lens; 1/125 at f2.5; Kodachrome 25.

■■
What is a slide sandwich and how is it made?

A slide sandwich is in fact quite straightforward and simply involves placing two colour transparencies together to create a montage effect. As a rule it is best if both slides are slightly over-exposed and if one is essentially of a fairly even tone or colour and the other has a quite bold outline or shape to create a centre of interest in the combined image.

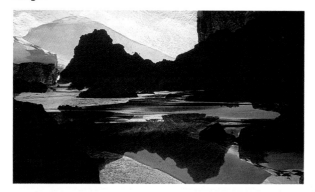

This sandwich was made from two transparencies of the same scene, one of which was reversed and inverted.

■■
Is it possible to photograph a silhouette without studio lighting?

One method which can be very effective is to position the subject against a well-lit window covered with some means of diffusion such as tracing paper and shoot against it. Outdoors you can shoot from a low angle with your subject in a shaded area against a bright sky. Calculate the exposure to give the minimum needed to create a white background.

Nikon F; 200 mm lens; 1/250 at f16; Ektachrome 64.

■■
What are multiple exposures and how are they made?

A multiple exposure is two or more images which are exposed on to the same piece of film. There are essentially two ways of making them. The first is to mask part of the image while shooting one subject and then to reverse the mask to enable you to expose the other section (a similar effect can be achieved by photographing subjects against a black background). The second method is to superimpose two or more images so that they blend together; each image has to be under-exposed to avoid over-exposure when the two exposures are combined. This method works best when one image is predominantly dark in tone and acts as a background to the more dominant image, for example a strongly lit portrait against a dark-textured wooden background.

This double exposure was made in a slide duplicator. The background image was given one stop less exposure than normal.

■■■
What is a physiogram and how is it made?

It is a pattern created by the movement of a light source and recorded with a time exposure. It can be done quite simply by suspending a flash-light in a darkened room over the camera position and letting it swing round.

The illustration (far left) shows the set-up of the light source and camera used for making this physiogram (left).
Left Rolleicord; 2 mins at f8; Ektachrome 200.

■■
How can I take double exposure shots with a camera that is obviously not designed with this facility?

You can always rewind the film after the first exposure and run it through again for the second, having carefully marked the starting position of the film when you first load it. With many cameras you will find that it is possible to wind the shutter without moving the film by pressing the rewind button at the same time.

■■
How do I set about taking pinhole pictures?

Pinhole pictures can be taken with a 35 mm SLR by fastening a piece of aluminium foil with the pinhole on to the camera body.

If you have a camera with an interchangeable lens then the easiest way is to remove the lens, make a very small, neat hole with a fine needle in a piece of tin foil and tape the foil over the camera body. Alternatively, you could make a small, shallow box to fit over a 110 cartridge and place the pinhole foil over this. It can be a lot more fun though more trouble, however, to make a pinhole camera out of any light-tight container; this could be anything from a cardboard box to a biscuit tin with the pinhole mounted at one end and the film taped on to the other end. This has to be done in the dark, of course, which restricts you to one shot at a time. Instead of film you can use a sheet of bromide paper to give a paper negative which you can print by contact on to another sheet to give a positive. This will require much longer exposures and as a rough guide you could try half an hour in bright light. Exposures will be largely a question of trial and error but with conventional film you could try a test at about 1000 times that indicated for an aperture of f8.

■■
What is meant by a collage?

In photography it normally means a combination print made up of individual images which are cut out and mounted together to a preconceived design. However, a collage can also include elements of non-photographic images such as fabrics and drawings.

■■■
What is the best way of getting grainy effects in a photograph?

You should select a fast grainy film to begin with and possibly accentuate its graininess by push-processing. It is also best to compose the picture so that it occupies only a small area of the frame and can be substantially enlarged; one way of doing this is to frame the shot using a standard lens and then switch to a wide-angle for the exposure. It is also important to ensure that the print or duplicate transparency is critically sharp when you are making the enlargement to bring out the true gritty effect of the grain.

■■■
Is it possible to take pictures with a strobe lamp like those used at discotheques?

Yes, although strobe lamps are of rather low power compared to an ordinary electronic flash and you will need to use the lamp quite close to the subject and/or use a fast film. The method is to arrange the lamp and the moving subject in a darkened room, set the lamp to the required number of flashes per second, and then simply hold the shutter open on a time exposure for the duration of the movement.

■■■
What is the best way to get zoom effects?

This is done by altering the focal length of a zoom lens during the exposure, and since it is easier to control with slower shutter speeds it can help to have the camera on a tripod. The effect works best when you have a quite clearly defined subject against a background of a contrasting tone or colour. Frame your picture so that the subject is centred in the viewfinder with plenty of background surrounding it, with the zoom set at its shortest focal length, then as you press the shutter release almost simultaneously pull the zoom back smoothly to its longest focal length. Aim to have about half the exposure static and half zoomed.

Nikon F2; 35–70 mm zoom lens; 1/5 at f22; Ilford FP4.

■■■
What is front projection?

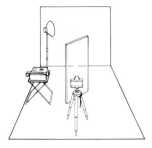

The illustration shows the set-up and arrangement of equipment needed for front projection.

It is a system which uses a beam-splitting device to enable an image to be projected along the optical axis of a camera on to a highly reflective screen placed behind the subject. In this way a colour transparency can be used as the background of a studio shot.

■■■
Can ultra-violet lights be used for photography?

Yes. Provided you shoot in a darkened room and the subject has fluorescent properties or is covered in fluorescent fabrics, paints, or dyes, it is possible to shoot on daylight colour film using a 2A UV filter to eliminate scattered UV light.

Photographing buildings

■■
What type of lighting is best for photographing statues and high-relief details?

A quite soft light from an angle of about 45° to the camera is likely to produce good modelling without excessive shadows. A hard light like direct sunlight should be avoided as dense, well-defined shadows are likely to obscure detail and create excessive contrast.

■■
What are the regulations about taking pictures inside public buildings and churches?

The regulations vary considerably and there is no fixed norm. In some places you may be allowed to take pictures, but without the aid of flash or a tripod. You can either enquire first or simply be very unobtrusive and shoot a few frames discreetly, stopping if requested, but you should obviously not ignore any notices which expressly forbid photography.

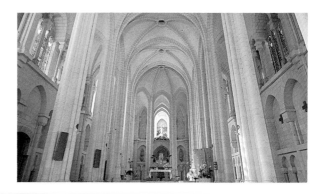

Nikon F; 24 mm lens; 1/2 at f5.6; Ektachrome 64.

■■
How can I avoid converging verticals?

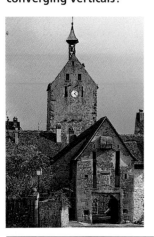

The solution is not to tilt the camera upwards but to keep it perfectly parallel to the face of the building; this will mean either including a large area of foreground and/or moving further back. Another solution is to use a very distant viewpoint combined with a long-focus lens which will eliminate the perspective effect which creates converging verticals. In some cases you can find a higher viewpoint so that you photograph the building from a point approximately level with its centre. If all these solutions are impractical you will have to use either a view camera or a perspective control lens.

Nikon F3; 150 mm lens; 1/125 at f8; Ektachrome 64.

What is the best way to deal with converging verticals when shooting tall buildings?

It is possible to make a virtue of the effect, in which case it is generally best to exaggerate it further by approaching the building even more closely and increasing the tilt of the camera. A wide-angle lens will enhance the effect still more and in some cases you can tilt the camera to one side as well as back to add further emphasis. This technique is not usually pleasing if the base of the building is included since it can easily look as if it is falling over. It is often more effective if the sky has some interest, like a deep blue or dramatic clouds, and if you use a compositional frame such as the overhanging branch of a tree.

Nikon F3; 20 mm lens; 1/250 at f8; Ektachrome 64.

I want to photograph some stained-glass windows. Are there any special problems?

You should avoid direct sunlight falling on to the window as this will create excessive contrast. A deep blue sky will create a colour bias, and in fact a slightly overcast sky is ideal. It is impossible to obtain detail in both the window and interior details so it is best to frame the picture quite tightly and also make sure that the dark tones of interior details do not influence the exposure reading. Since photographing most windows will involve tilting the camera upwards a long-focus lens which enables a more distant viewpoint will prevent excessive perspective effects.

■
How can reflections of windows be avoided when taking pictures of buildings?

Careful choice of camera viewpoint is the first step, and it is also necessary to look quite hard since many distracting reflections will not be noticeable at the time the picture is taken; these will show up if you view the image with the lens stopped right down. Reflections that cannot be avoided by this means can often be eliminated or reduced by the use of a polarizing filter.

■■
How can I avoid getting blurred images of people when taking pictures of interiors and fast shutter speeds are not possible?

The best method is in fact to give very long exposures. If you select a small aperture and use a slow film and give exposures of a minute or more, then moving people will simply not record on the film.

■■
What is the best type of lighting for photographing decorative architectural details?

As a general rule, a fairly soft but directional light will be best, for example from an overcast sky or possibly hazy sunlight. Bright, direct sunlight is likely to create excessively dense and defined shadows with all but the most subtle reliefs.

Olympus OM1; 50 mm lens; 1/60 at f5.6; Ilford FP4.

■■
Can I use flash to take pictures of architectural details?

Yes, but you will be restricted to fairly close viewpoints with the normal small battery-powered flash-guns. You can either use the flash to fill in the shadows created by daylight when it is too contrasty, or with interiors you might use it as the sole source. In these circumstances, however, you will find that it will probably be necessary to direct the flash from an angle rather than from the camera position in order to create more modelling in the subject and either diffuse it or bounce it from a white surface in order to prevent the shadows from becoming too hard and dense.

■■
How can illuminated buildings be photographed without loss of detail in the surrounding area?

This can be done very easily by taking the pictures before it is completely dark; at dusk, for instance, the residual daylight will allow details to be recorded in the shadow areas and if the exposure is calculated correctly the impression will still be of a night shot. In situations where the illuminations are not switched on until after dark it is possible to set the camera up on a tripod and make an exposure in daylight, giving about 3 stops less than the correct setting, and then when it is dark making another exposure on the same piece of film with the correct exposure calculated for the illuminated details.

■■
How can unattractive foregrounds such as parked cars be avoided when photographing buildings in urban situations?

One solution is to find a higher viewpoint which will enable you to shoot down slightly, creating more separation between the building and the foreground. Alternatively, you may be able to find a more distant viewpoint with a close foreground such as foliage which you can use as an out-of-focus screen to mask the distracting elements. A third possibility with an illuminated building is to shoot at dusk or after dark when the foreground will be lost in shadow.

■■■
Is it possible to photograph a stained-glass window and also show detail in the interior of a church?

Yes it is, but you will either need to have sufficient lighting to raise the level of illumination in the interior to that of the window, or you will have to wait until the daylight reduces in brightness to a point where it matches that of the available light inside.

■■■
Is there any way of avoiding people when shooting a busy building exterior in daylight?

Since it is usually not possible to give very long exposures in daylight conditions, one possibility is to give a cumulative exposure. For example, instead of giving say 1/5 sec you could make 20 separate exposures on the same piece of film at 1/1000 sec; this would give the equivalent exposure for the building but any elements that did not remain static would not record since the individual exposures would drastically under-expose them. In practice you may need to give rather more exposure by this method as reciprocity failure also occurs with the cumulative effect of brief exposures.

Holiday and travel photography

■
I shall be crossing the Alps by plane and would like to take some shots from the window. Is it worth the attempt?

If the conditions are clear it could well be worth while. It would be an advantage if it were early or late in the day when the sun is at a more acute angle as this will create more contrast and emphasize the contours; otherwise use an 81A filter to overcome the blue cast caused by ultra-violet light (you may find that a polarizing filter will also help). If you can, use a fairly fast shutter speed of perhaps 1/250 sec to overcome any vibration, and hold the camera as close to the window as possible without touching it; you should also try to find a window that is not too scratched. It often adds to the effect and interest of the shot if you can include part of the plane in the frame, for example the wing.

■■
I want to take some pictures of the shoreline from a boat. Are there any special points to watch?

You will have to use a fairly fast shutter speed of perhaps 1/250 sec or less, especially if the boat is travelling quickly or the water is rough. If you are shooting at right-angles to the direction in which the boat is travelling, then it will be necessary to pan the camera so that the scene in the view-finder remains static and does not move across it. You should also be careful to remove any spray from the camera and lens, especially if it is a sea trip as salt water is particularly harmful to equipment.

■■
When taking pictures at the seaside I find that the exposure meter usually gives unrealistically high readings. Why does this happen and what should I do about it?

This happens because the very light surroundings of sand and water cause a great deal of light to be reflected and scattered, and this will influence the meter. It is best to take very close-up readings from a mid-tone in the subject and to avoid the inclusion of any very light areas or highlights in the meter's field of view.

Nikon F2; 150 mm lens; 1/250 at f8; Ektachrome 64.

■■
What is the best way to emphasize height when taking views from tall buildings?

The most effective way is to include some quite close foreground details such as a window-frame or even a person as this will emphasize the effect of perspective. This will be further enhanced if you use a wide-angle lens.

Nikon F3; 28 mm lens; 1/125 at f8; Ektachrome 64.

■■
I am going on holiday in the Tropics. What special precautions should I take?

Humidity and heat are both harmful to film and you must take measures to keep it cool and dry; store the film in sealed packs together with a desiccant such as silica gel to absorb moisture. The camera should also be kept free from moisture in a camera case with a reflective surface and a rubber waterproof seal; put a desiccant in the case with the equipment. Keep both film and cameras away from direct sunlight and be careful to avoid leaving them in the boot of a car for any length of time where the temperature can become extreme.

Nikon F3; 150 mm lens; 1/250 at f8; Ektachrome 64.

■■
What effect does high altitude have?

Low temperatures can adversely affect the performance of batteries. Condensation is also a problem when equipment is subjected to rapid changes of temperature, for example when you take it from a warm hotel room out on to a cold wind-swept mountain. Ultra-violet light can create a blue cast on colour film so you should use a UV or 81A filter. On sunny days with blue sky the clear atmosphere of high altitudes can also produce very contrasty lighting.

Nude and glamour photography

■■
How do professional photographers convey such a strong sense of skin tone and texture in nude shots? Is it difficult?

It is not difficult but it does require a careful control over the quality and direction of the lighting as well as good camera technique. Skin texture is quite subtle and a very precise angle of lighting is needed to reveal it effectively, and since you are dealing with a mobile subject it is necessary to be constantly aware of this. As a general rule, a fairly soft but acutely angled light is most effective and precise exposure and crisp images are necessary to maximize the textural quality of the picture. You will also find that the impression of skin texture is often heightened when it is juxtaposed with contrasting textures such as fabrics, for example, and it will often be emphasized if the model's skin is lightly oiled or is wet.

■■
I am organizing my first nude session with a girl friend who has not modelled before. What advice should I give her concerning preparation, make-up, and so on?

In these circumstances I would suggest you keep make-up as minimal and as natural as possible, with at the most a little tinted foundation and powder to create a smooth, unblemished skin tone and a little lip colour and eye liner for definition on the face, with perhaps a little shading on the cheekbones. It is best not to attempt anything more elaborate unless you have an experienced hand to help. For nude shots the most important thing is to avoid unsightly indentations in the skin caused by clothing, so clothes should be removed well in advance of shooting.

Rolleiflex SLX; 150 mm lens;
1/250 at f5.6; Ilford FP4.

What is the best way of finding a suitable model for a first nude session?

Your question implies that you do not think that any of your acquaintances would be either agreeable or suitable, in which case you might enquire at a local art school since it is likely to have a list of life models. Alternatively, there are many advertisements in magazines for amateur studio clubs who as well as offering studio facilities also have a register of photographic models, either amateur or semi-professional. Of course, if you are prepared to pay professional fees you can approach one of the many model agencies who have girls, and boys, who will do nude work.

I would like to try some abstract nude shots. What is the best way to start?

The term 'abstract' in relation to the nude can mean anything from a model's head just turned away from the camera to an image that is completely unidentifiable. A good way to start, however, and one that will enable you to view your subject in a different way, is to concentrate on just small areas of the body. You will find that you will be able to create a wide range of effects by just slight variations in the model's position, the camera angle, and by varying the lighting. A long-focus lens will be helpful as it will allow you to frame quite tightly without having to use a very close viewpoint. You will find a tripod a positive asset for taking this sort of shot, both to allow precise aiming and focusing and also the use of slower shutter speeds without the risk of camera shake, since a small aperture will usually be needed to obtain adequate depth of field with close-up images.

Nikon F3; 150 mm lens; f16 with studio flash; Ilford FP4.

Rolleiflex SLX; 150 mm lens; f16 with studio flash; Ilford FP4.

Darkroom techniques

Processing film

■■
What is meant by the time and temperature method?

This simply refers to the relationship between the temperature of the solutions and the time required for processing. The higher the working temperature the shorter the development time.

■■
Is it more difficult to process colour film than black-and-white?

No, not really, as obtaining optimum results from either process requires precise control of times, temperatures, and agitation. However, an error with a black-and-white film is less likely to have such a significant effect as an error with colour film.

■■
I have a great deal of trouble maintaining the high temperatures needed for colour processing. Even though I get the temperature right to start with it often drops considerably during the process. What can I do?

The most effective way of maintaining temperatures is to buy a large plastic bowl and fill it with water at the required temperature and keep all solutions and the developing tank in it throughout processing. For a long session it could also be worth while buying a thermostatically controlled heater for the water bath, of the type used in tropical fish tanks.

Placing all the solutions and the developing tank in a bowl of water helps to maintain the correct temperature for processing.

■■
Is there a recommended way of drying film after processing?

The safest method is to add wetting agent to the final rinse and just hang the film up with a weight on the end in a clean, dry, and slightly warm atmosphere and let it dry naturally. If you are in a hurry then you can remove the surplus moisture from the surface of the print with a special squeegee and place it in a heated room or drying cupboard; you must ensure that the squeegee is perfectly clean and that no drops of water are left on the film.

■■
Is it necessary to have a darkroom in order to process your own film?

No. Providing you have a dark place where you can load the film into the daylight developing tank, such as a cupboard or even under the bedclothes, then the process itself can be carried out in daylight. Alternatively, you can use a changing bag into which the film and tank are placed and the loading carried out through light-tight armholes.

A changing bag with light-tight armholes.

■■■
On printing some black-and-white negatives that had recently been processed I noticed some small, round, dark spots on the print. What could have caused them?

This is almost certainly due to air bells forming on the surface of the film as it is immersed in the developer. It can be prevented by agitating the film as soon as all the developer is poured in, and also by tapping the side of the tank sharply several times to dispel any remaining air bells.

■■■
Some black-and-white negatives of a landscape I have processed have bands of varying density in the sky area which appear to come from the sprocket holes. What has caused this?

These sound like flow marks and are usually caused by excessive and too vigorous agitation. The problem seems to be more prevalent with metal spirals, especially when a number of films are processed together.

■■■
Is it a useful device to alter the development of black-and-white film?

If the entire film has been shot under the same conditions and exposure it is possible to increase the contrast by extended development and to reduce it by giving shorter times than those recommended. It is also possible to regulate the speed of the film by using a different type of developer or by adjusting the processing times.

■■■
I noticed staining on some film I had processed. What might have caused it?

The most probable cause is contamination from containers or mixing jugs which have not been properly cleaned. It is best to keep specific vessels for specific solutions, but it is also possible that the stains may have been caused by stale solutions.

■■
**I have developed some
very thin negatives. How
can I tell if they are
under-exposed or
under-developed?**

If they are under-developed there will be some details
visible in the shadow area whereas with under-exposure
there will be clear film in these tones.

Top An under-developed
negative; **bottom** an under-
exposed negative.

■■
What is the purpose of the concertina type storage bottles used for processing solutions?

Some chemicals, developers in particular, are likely to oxidize and deteriorate when left in contact with air. The bottles you describe can be compressed to exclude air as the solution is used and the quantity of liquid diminishes, whereas a rigid bottle would allow a progressively greater amount of air to be retained.

Concertina type bottles are a practical way of storing processing solutions.

■■■
What is meant by 'pulling' in relation to film processing?

It is the technique of reducing development times in order to bring about a reduction in the film speed to compensate for over-exposure. Similarly, the term 'pushing' is used for uprating a film to increase its ISO rating or to compensate for under-exposure.

■■■
What is meant by a clip test?

It is a method of checking exposure in which a complete roll of film of the same or a similar subject is given a constant exposure and one or two frames are cut from the end and processed first. The remainder of the film can then be processed with amended times to adjust the speed of the film as required.

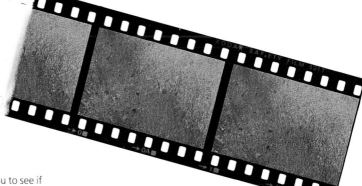

A clip test enables you to see if any adjustment is needed for the rest of the roll of film.

Making black-and-white prints

■■
How much space is needed for a home darkroom?

It is possible to manage in a very small space, even as little as about 4 × 5 ft (1 × 1.5 m), although this would not be very comfortable. You will need room for the enlarger which will occupy about 2 square feet (0.2 square metres) and a line of three dishes of about 8 × 10 in (20 × 25 cm) which will take up about 1 × 3 ft (0.3 × 0.9 m), although you can buy a tiered stand for stacking the dishes. The fixed prints can be transferred afterwards to another room for washing and drying.

■■
What are the different grades of printing paper and what are they for?

Below The same negative was printed on to soft (left), normal (centre), and hard grades of paper (right).

They are designed so that different degrees of contrast in individual negatives can be adjusted. A negative of normal contrast can be printed so that detail is visible in both the lightest and darkest tones on a Grade 2 or normal paper, but a negative of higher contrast would need to be printed on a softer grade of paper such as a Grade 1 or 0 to retain these details. Similarly, a soft negative printed on a normal Grade 2 would show whites as grey and blacks without full density and would need to be printed on to a harder grade such as 3 or 4 to increase the contrast. The different grades of paper can also be used to create a variety of effects by altering the tonal range of a normal negative.

■■
How can I tell which is the emulsion side of films and printing papers?

You can identify the emulsion side of printing paper by touching one corner with the tip of a moistened finger and thumb: the emulsion side will feel slightly tacky. The emulsion side of film is slightly matt compared to the shiny back, and in the dark it will be on the inside of the film's curl.

■■
How can I remove finger-marks from film before printing?

If the marks are on the back, not the emulsion side, then you can often remove them by just touching a finger-tip against the side of your nose and gently polishing the marked area, as the natural oil in the skin is very effective for cleaning film. If the marks are on the emulsion side then they are best removed by gently applying a little carbon tetrachloride with a cotton bud and wiping them carefully.

■■
I have trouble getting fibre-based black-and-white prints to dry flat. Is there a special way?

The best method is first to wipe the print with a special squeegee and then dry it in a flat bed or rotary dryer. Remove the print before it is 'crisp' dry and place it under a weighted board for a few hours. If you do not have a dryer it will help to peg two prints back to back on a line and to clip the two lower corners together; this will help to stop them curling as they dry. When they are almost dry they can be put under a weighted board in the normal way.

■■
How can I check that my safelight is safe?

This can be done quite simply by taking a small piece of enlarging paper, placing an opaque object like a coin on it, and leaving it in the light of the safelight for about half an hour and then processing it in the normal way in darkness. If there is any trace of fog the shape of the object will show up quite clearly.

■■■
I would like to print my own black-and-white negatives. What equipment would I need?

You can make contact prints with a very minimal outlay. You will need four dishes of 8 × 10 in (20 × 25 cm) or larger, a piece of flawless plate glass about 10 × 12 in (25 × 30 cm), a light source such as a desk lamp, and a safelight or red safe light bulb. You will also need a means of timing in seconds and a photographic thermometer, and of course the necessary materials: a packet of 8 × 10 in Grade 2 bromide paper, a suitable paper developer, and fixer and a stop bath. It would also be useful to have some print tongs or rubber gloves, a hose for washing the prints, a line and pegs on which to hang them, and a special squeegee to dry them. For making enlargements you would of course need an enlarger with a suitable lens.

■■■
What is the procedure for making contact prints?

First cut the film into suitable strips: for 35 mm this would be six frames and for 2¼ in, three or four frames. By the light of the safelight, position a piece of bromide paper emulsion side up (if in doubt, it will feel a little sticky to a moistened fingertip), then place the strips of film side by side on the paper emulsion (matt) side down, and on top of this the piece of plate glass. Now make an exposure with a light directly above. The first attempt will be purely trial and error; make a strip test by giving a series of exposures and progressively covering the paper with a piece of card (with a 20-watt bulb 3 feet (1 metre) away you could try 1–2–4–8 seconds). The paper can then be processed in the recommended way.

■■■
I have seen black-and-white prints on fabric. How can this be done?

It is possible to buy a black-and-white emulsion which is coated on to a linen base and can be used just like ordinary bromide paper; once processed, the print can be treated (with care) just like ordinary fabric and used for cushion-covers or even curtains. An alternative method is to use a liquid emulsion which can be obtained from some suppliers to coat a fabric of your choice.

■■
Should darkroom walls be painted black?

If the darkroom is efficiently light-tight and you are using the correct safelight it is best if the walls are white to maximize the amount of safe light. However, the area around the enlarger is best painted matt black to minimize reflections during exposures.

■■
I sometimes find that exposure times are too short to control accurately when making small prints. What can I do?

With black-and-white prints you can simply replace the enlarger lamp with a low-powered bulb. Alternatively, and for colour printing, you can fit a neutral density filter over the enlarger lens.

■■
Is it necessary to use a stop bath when making black-and-white prints?

No, rinsing the prints in water will do, but a stop bath can help to prevent staining and will prolong the life of your fixing bath.

■■■
What is the best procedure for ensuring maximum permanence for black-and-white prints?

The following method is recommended for archival permanence suitable for museum and gallery prints: 1. use fibre-based paper such as Ilford Gallerie or Agfa Brovira; 2. give full development to completion as recommended for the solution and paper in use; 3. use a stop bath for at least 10 seconds, preferably one with an indicator so that it can be discarded when stale; 4. use two fixing baths with 5 minutes in each and discard the first as soon as it has had the equivalent of forty 8 × 10 in (20 × 25 cm) prints per litre of solution, replacing it with the second bath which should then be filled with fresh solution; 5. give a brief rinse in running water and then transfer to a hypo clearing bath for 2 minutes with continuous agitation; 6. rinse for a further 5 minutes in running water, then transfer to a selenium toner such as Kodak Rapid Selenium Toner for about 5 minutes; 7. wash for at least 30 minutes in running water.

■■■
Is there any way in which the highlights of a print can be brightened where it is not possible to dodge satisfactorily?

Yes. Immerse the print briefly in a dilute solution of Farmers reducer, then transfer it to a fixing bath to arrest the action. Wash the print in the normal way. The solution can also be applied locally with a brush or cotton swab.

■■■
I have some very grainy negatives caused by over-exposure. Is there any way of minimizing the effect in the printing?

The effect of grain will be lessened by printing on an enlarger which has a diffuser head rather than a condenser. You can also introduce a degree of diffusion by stretching a piece of nylon mesh across the enlarging lens. Another way to minimize the effect is to print on to a soft grade of paper or one with a textured surface.

■■■
What is the best way to decide how to crop a picture? I often find it difficult to judge on the baseboard.

First make a print from the whole negative area. Then cut out two L-shaped pieces of black card and place them over the print, adjusting them so that you see the exact effect of different crops.

■■■
Can black-and-white transparencies be made from colour negatives?

Yes, you can simply print them on to a conventional panchromatic negative film such as Ilford FP4 or Ilford Tri-X.

■■■
My prints always appear too soft whatever grade of paper I use. Why is this?

The answer is almost certainly fog due to an unsafe safelight, light leak from the window or door, or light spill from the enlarger. Occasional problems of this type can be caused by stale developer or by using too low a temperature during processing.

Loss of clarity and detail are typical problems of a soft print.

Special printing techniques

■■
What is a montage?

A montage is an image which is created by printing two or more negatives or transparencies on to one piece of film or paper to create a single picture.

This montage was made by printing a vignetted eye into a hole which had been shaded out of the sky area of the landscape image.

■■
What exactly is a photogram?

It is a method of creating a photographic image without the use of a negative or a camera; both opaque and translucent objects are used to create shapes and patterns directly on to the paper or film with the aid of a light source.

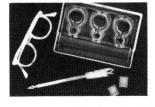

The photogram was created by positioning the objects on bromide paper under the light source of an enlarger. The varying density and opacity add interest to the image.

■■■
What is a texture screen and how is it used?

This is a piece of film or translucent fabric which is placed in contact with the negative and a print then made from this sandwich. It is possible to buy sets of ready-made texture screens that will give the effect of a variety of familiar surfaces such as silk, hessian, etc., but you can also obtain a wider range of effects by making your own. You can, for example, photograph a textured surface and use a weak negative or positive of this printed on a piece of negative film as the texture screen.

■■■
What are the various ways of distorting a print to alter the effect of the image?

This can be done very easily by altering the angle of the printing paper and/or the masking-frame during the exposure. Instead of having it parallel to the negative in the normal way it can be tilted at an angle, for instance, or even curved or crumpled and held in place with clips. A small aperture will be needed to get a sharp enough image on the print. It is also possible to obtain interesting effects by moving the paper or even the focusing setting of the lens during the exposure and by placing textured glass or plastic such as hammered glass in contact with the paper.

■■■
How can a more interesting sky be added to a landscape picture?

An image of a sky was montaged on to an image of a landscape with a blank sky, and prints made from the separate negatives.

This is a fairly simple type of montage print. The technique involves exposing the image from a separate negative of a suitable sky on to the same piece of paper on which the landscape has been printed before development. Place a piece of drawing-paper the same size as the print you require into the masking-frame, size up and focus the landscape negative on to this, and trace the main outlines on to the paper with a black pen or pencil. You can now make a test strip from this negative in the normal way. Next replace this negative with a suitable negative of a sky and size up and position this on to the tracing of the landscape image, and make a test strip of this second negative. When both exposures have been determined you can make the montage. Take a piece of bromide paper (mark one corner so that you know which way round it is placed in the masking-frame) and expose the sky negative on to this sheet, gently vignetting with your hand or a piece of card the point where it will meet the horizon of the landscape image to prevent a hard edge. Place this exposed sheet in a light-tight box and replace the landscape negative into the enlarger and resize and position it on to the tracing in the masking-frame, making sure it is in exactly the same position as before. Replace the half-exposed sheet of paper into the frame (ensuring that the marked corner is in the right place) and expose it, holding back or shading out any unwanted details in the sky area, and then develop the exposed print.

■■■
What is meant by burning-in in printing?

It is a technique in which the hands or a hole in a piece of card are used to give additional exposure to a selected area of a print.

The quality of the picture (right) has been improved by printing in the sky area quite heavily (far right).

■■■
What is meant by 'flashing' in darkroom work?

It is a method by which a sensitive material such as film or printing paper is given a very brief exposure to light in order to reduce the image contrast.

■■■
What is a gum bichromate print?

It is an old process in which a contact print is made from a negative, usually by exposure to sunlight, on to a paper which has been sensitized with a mixture of gum arabic, potassium bichromate, and a water-colour pigment. The pigment which is unaffected by the exposure is simply washed away with water.

Special darkroom effects

■■■
How do I tone a print?

The striking colour effect of this picture has been obtained by using the blue toner of a ColorVir toning kit.

This is a relatively simple procedure and can be done in daylight with any black-and-white print that has been well processed and washed. Methods vary between individual kits: with some the print has to be bleached first and then redeveloped, with others only a single bath of toner is used. Some kits enable a variety of toners and dyes to be combined on a single print to create multi-coloured effects.

■■■
What is meant by dodging?

It is a printing technique in which a small piece of opaque material on a wire support is used to hold back the light from part of the image during an exposure.

■■■
What is bas-relief?

It is a technique in which a negative and positive are printed together slightly out of register to create an impression of three-dimensional relief.

■■■
What is meant by a bleach-out in photographic printing?

It is a term used to describe printing on to high-contrast Lith materials to reduce an image to tones of pure black-and-white.

■■■
What does blocking-out mean in retouching?

It is the application of an opaque ink to a negative. This prints as pure white, obscuring unwanted details and creating a white background, or filling in dust spots.

■■■
What are the various methods of producing a coloured image from black-and-white negatives?

Chemical toning can produce a wide range of colours from a conventional black-and-white print, from the familiar sepia to brown, red, blue, and green. This process affects the tones of the print in proportion to their density and leaves the whites unaffected. Ordinary fabric dyes can be used to colour the light areas of the print, and black-and-white papers on a tinted base are also available. Coloured retouching dyes or oil paints can be applied with a brush to hand-colour black-and-white prints selectively, and black-and-white negatives can be printed on to colour papers or films with the use of colour filters to create a range of hues.

This simple but effective image was created by hand-colouring.

■■■
What are the techniques used to produce a tone separation?

This process involves making two or three Lith positives from an ordinary black-and-white negative and then printing these successively by contact and in register on to a sheet of ordinary half-tone film to produce a negative which will record just white, black, and one or two flat tones of grey depending on whether two or three Lith negatives were used.

■■■
How is a solarized print produced?

A true solarization is produced by massive over-exposure causing partial reversal, but a similar result can be produced by the Sabbatier method where a print or a negative is re-exposed to light half-way through development. A similar effect can be created by the use of a special film called Agfa Contour. Another method is to use a chemical solution such as the one in the ColorVir toning kit.

Making colour prints

■■
I would like to try colour printing. Is it much more difficult and expensive than black-and-white?

No, in some ways it is much easier, and it is possible to make colour prints with very little additional equipment. Most darkroom workers now process prints in light-tight drums, rather than dishes, and this means that the only step you need to carry out in the darkroom is the exposure of the paper. Once you have loaded the paper into the drum, you can turn on the light – or even process the print in another room. Most modern colour processes are also much more tolerant of variations in solution temperature than their predecessors.

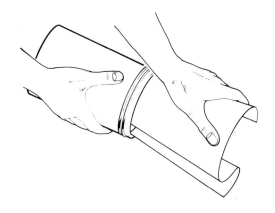

Curled around the inside of a print drum, a sheet of colour paper can be processed with just a cupful of chemicals. This makes drum processing much more economic than development in dishes.

■■
For a beginner would it be best to try printing from colour transparencies or colour negatives?

Colour transparencies, partly because the process is more tolerant of exposure and colour variations and once you have established a basic exposure and filtration it will not vary much for similar transparencies, and also because with a colour transparency you have a reference against which to compare your tests.

■■
Prints made from colour transparencies are often too contrasty. How can I alter this?

It is sometimes possible to reduce the contrast by reducing the first development time, and another method is to give the print a very brief exposure to white light before processing it. The method used in laboratories is to make a contrast mask; this involves producing a weak negative image on black-and-white film from the transparency by contact and printing through a registered sandwich of the two. In many cases it can be effective simply to shade the print by giving extra exposure to the darker areas.

■■
What is meant by additive colour?

It is the way in which a full colour image is produced by adding the three colours red, green, and blue.

■■
What additional equipment to my black-and-white set-up will I need for colour printing?

You will need colour paper and chemicals, a set of colour printing filters (or a colour head for your enlarger) and a print processing drum.

■■
Is the filtration the same for both colour transparency and colour negative printing?

No. With colour negatives you use a filter of the same colour as the cast to remove it and with transparencies you must use a filter of the opposite or complementary colour, i.e. a cyan filter to correct a red cast.

■■■
Is a colour analyser necessary for colour printing?

It is really not at all necessary for printing from transparencies, but if you are making large numbers of prints from different and varied colour negatives then it could be an added convenience.

A colour analyser has a light-sensitive probe that can measure individual areas of a negative, or can give an average of the range of tones.

■■■
Is the same process involved in making prints from transparencies and negatives?

No, the two are quite different. The most important difference is that the methods of adjusting exposure and colour balance are reversed. With a print from a colour negative, for example, you must give extra exposure to make the print darker and with a print from a colour transparency you must give less. To remove a colour cast from a print from a negative you should use a filter of the same colour, whereas with a print from a colour transparency you should use a filter of the opposite colour, i.e. a cyan filter to remove a red cast.

■■
Do colour prints fade more quickly than black-and-white?

Black-and-white prints are the most stable of all, but most of today's colour print materials will not fade for at least 20 years unless they are exposed to direct sunlight. Cibachrome and Polaroid prints are especially resistant to fading.

■■■
What is a dye transfer print?

This is a method of making high-quality colour prints by transferring the dye retained in a gelatin matrix on to a sheet of receiving paper. Three separate images in cyan, magenta, and yellow are transferred in register to create a full colour photograph.

Materials and equipment

■■
Is it essential to have running water in a home darkroom?

No, although it is obviously more convenient. Most processes can be carried out with water in containers and prints or films transferred to another room after fixing for washing in running water, when white light will not harm them.

■■
What is meant by quarter plate?

This is a term describing a standard size of material which is no longer widely used today. Whole plate is $8\frac{1}{2} \times 6\frac{1}{2}$ in, half plate $6\frac{1}{2} \times 4\frac{3}{4}$ in, and quarter plate $3\frac{1}{4} \times 4\frac{1}{4}$ in.

■■
What is hypo?

It is the abbreviated name of a chemical used in the early days of photography for fixing the image, and now used as a general term for a fixing solution.

■■
What is a wetting agent?

It is a chemical which is added to a liquid to reduce its surface tension. When used in the final wash of a film it speeds drying and prevents the formation of drying marks.

■■
What is a one-shot developer?

It is a developer which is used only once and then discarded so that fresh solution is used each time. It is the system used in most drum processors for colour prints and ensures constant results.

■■■
What is Farmers reducer?

It is a solution of potassium ferrocyanide and sodium thiosulphate, or hypo, used to bleach the silver image in a print or negative.

■■■
What is a monobath?

It is a combination of developer and fixer which enables a single solution to be employed for processing black-and-white film.

■■■
What are the points for and against fibre-based enlarging papers as opposed to plastic-based?

Most photographers agree that both the image quality and the finish of a fibre paper are superior and permanence is more assured. However, plastic papers are easier and quicker to process and to dry flat.

■■■
What is a chlorobromide paper?

It is a black-and-white printing paper in which both silver bromide and silver chloride are used in the emulsion to give a slightly warm, brownish image.

■■■
What is a Universal developer?

This is a developer that can be diluted for processing both black-and-white films and printing papers.

■■■
What is an intensifier used for?

It is a chemical method of increasing the density of a silver image which has already been developed. It can be used to save very thin negatives.

■■■
What is Lith film, and what is it used for?

It is a very high contrast film, or paper, which when processed in the special developer will record an image in just solid black and pure white. It is used mainly in photomechanical reproduction processes such as plate-making but can also be used for creative effects.

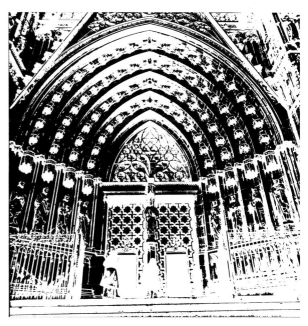

Right A Lith negative; **Below** a print made using a Lith negative.

■■
What are the main points to look for when choosing an enlarger?

The lamphouse should illuminate the largest intended negative area completely evenly and the negative carrier should hold the film quite flat and parallel to the baseboard and should be designed so that there is no danger of the film being scratched. Make sure that the enlarger column is long enough to provide adequate enlargement for the largest prints you will want to make and is at the same time quite rigid. Check too that the height adjustment of the lamphouse and the focusing mechanism are smooth and positive and that the enlarger is fitted with, or that you select, a good-quality enlarging lens. For colour printing ensure that if the enlarger does not have a colour head it does at least have a filter drawer above the condensers or negative carrier.

■■
What is an enlarger with a colour head?

This is an enlarger that has a filtration system built into the lamphouse; it can be adjusted by dials rather than with the use of separate filters.

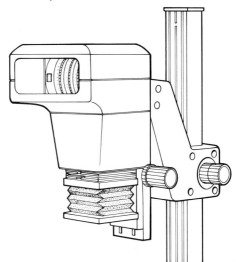

An enlarger with a colour head. The filtration system is adjustable by dials.

■■
What are the advantages and disadvantages of condenser over diffuser enlargers?

The condenser system tends to produce a sharper image with higher contrast while the diffusion system has the advantage that it minimizes scratches and dust on the film.

■■
Is an enlarger with a colour head essential for colour printing?

No, it is not essential. A set of gelatin colour printing filters can be used quite successfully and for making prints from colour transparencies would probably be almost as convenient. However, for printing from colour negatives where small adjustments to the colour balance are often needed a colour head would be preferable.

■■■
What is variable contrast printing paper, and how does it work?

It is a bromide paper with a special emulsion which alters its contrast according to the colour of the light which is used to expose it.

These two pictures are examples of the contrast range which can be obtained with Ilford Multigrade bromide paper.

After-work

■
What is a slide duplicator?

In its simplest and least expensive form it is an attachment for an SLR that fits in place of the lens and allows the camera to focus on a slide which is placed in a holder fitted with a diffusion screen, allowing it to be illuminated by an external source such as daylight. More elaborate versions have a special light box with flash or tungsten light and an arm to support the camera; this type can be used with the camera's own lens and an extension tube or bellows unit.

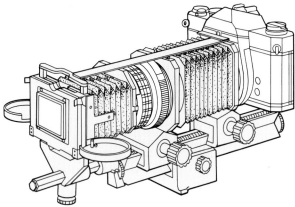

Above A simple attachment comprising a supplementary lens and sliding tube which fits on to the camera lens; **right** a more elaborate device for use with a bellows unit.

■■
Is it difficult to make duplicate transparencies, and is special equipment necessary?

Making duplicate transparencies is no more difficult than making a colour print. If you have an enlarger you can make duplicates by printing on to film instead of paper, or you can make duplicates by contact. It is best, however, to use the special duplicating film available in both 35 mm rolls and sheets from Kodak as this is designed to avoid the increase in contrast which would result from using ordinary transparency film. If you want to make duplicates in the camera you will need at least a 1:1 ratio close-up attachment such as a bellows unit, a macro lens, or extension tube as well as a light source and an opal diffuser. Alternatively, you can buy a slide duplicator which can be fitted to most SLRs in place of the lens.

■■■
What special effects can be created by the use of duplicate transparencies?

Duplicate transparencies are a simple and effective way of creating multiple exposures as it is possible to pre-select the images for superimposition; this is more accurate than superimposing directly from the subject. If duplicates are made in an enlarger it is also possible to use shading and dodging to improve the effects. A duplicate is a useful way of finishing a slide sandwich and you can also change the contrast of a transparency with a duplicate, as well as altering the colour balance, density, and composition.

■■■
How can duplicate transparencies be used to correct faults in the original?

First of all, establish a basic exposure and filtration for a normal slide and then evaluate the fault in the one you want to duplicate. You can try to make any corrections by using the opposite 'mistake' when you duplicate it; for example, a slide that is one stop under-exposed would have to be over-exposed by one stop compared to your basic exposure for a normal slide, and one that had a blue cast would need a corresponding yellow bias in the duplicate to balance it. It may not be quite as simple as this, however, and you may need to make an initial test, but this approach will still get you quite close to a corrected slide. Although colour casts can be effectively corrected there is a limit to the degree of correction possible to exposure errors since if detail is lost in highlight or shadow tones it is not possible to retrieve them. In addition to correcting exposure and colour faults it is also possible to correct or improve poor composition by enlarging and cropping the original transparency.

These two shots demonstrate how an original colour transparency (below) can be cropped to alter the composition (below right).

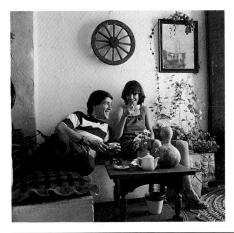

■■■
Is it difficult to retouch prints, and what equipment is needed?

The technique is not difficult although it does require a little patience. You will need a selection of retouching dyes or water-colours – just black for black-and-white prints and a selection of colours for colour prints – and a number of very fine sable brushes and a scalpel with spare blades. Black marks on the print can either be bleached with the appropriate solution (obtainable from photographic suppliers), applied carefully with a fine brush, or they can be gently scraped or shaved with a sharp scalpel held at an oblique angle so that the layers of emulsion are gradually removed until the mark matches its surroundings. White marks are more easily removed by taking up a tiny amount of the appropriate pigment on to the tip of the brush so that it is almost dry and just stippling the spot, building up tone gradually until it matches the adjacent tone.

Special problems

Difficult situations
What went wrong
Useful information
Practical photography

Difficult situations

■■
What is the best way to copy a photograph?

It is best to work with a mounted photograph so that it is perfectly flat. Tape it to a wall at a comfortable working height (eye-level), then set up the camera on a tripod so that it is quite square-on and level, checking the sides of the print in the viewfinder to make sure they are parallel. Ideally, you will need two identical light sources placed equidistant each side of the print and about 3 feet (a metre) away, at an angle of about 45°. You can check that the illumination is even across the print by placing a pencil upright against its surface in the centre and making sure that both shadows are of equal density, or you can take close-up exposure readings from each corner.

The illustration shows the correct position of the light sources to ensure adequate illumination when copying a photograph.

■■
I would like to take some portraits that simulate the old-fashioned style. How can I get this quality?

The essence of this type of picture was quite soft lighting and image quality. Daylight indoors would provide the right feel to the lighting, and something like a simple draped background and a prop such as a pleasing old chair or a plant would be adequate for the setting. A soft-focus attachment would help to recreate the luminous quality of the old lenses and a slow, fine-grained film would retain the smooth image quality characteristic of the large formats they used. For shooting in black-and-white you could sepia-tone the prints, and if you were shooting in colour you could use a sepia filter like the Cokin. When making the prints you could complete the effect by vignetting them.

■■
How can I take pictures from a TV screen?

You should set up your camera on a tripod in a darkened room, ensuring that there are no reflections in the screen itself and that it is square on to the camera. For a normal result set the TV controls so that the image is of slightly lower than normal contrast. Using a shutter speed of 1/15 sec or less calculate the exposure required in the normal way; a TTL meter will give a good indication from a normal picture. Daylight film is best for shooting colour. Remember, too, that the controls of the set, especially when combined with a video recorder, can be used to produce some interesting and creative effects.

■■
What are the points to look for when shooting from a moving car?

Open the window if possible, otherwise hold the camera close to the glass without touching it. Use the fastest practicable shutter speed and pan the camera with the subject as if the subject were moving.

■■
Is it difficult to photograph lightning?

You can photograph lightning successfully with any camera that has a time exposure facility but you will need a tripod. Simply set up the camera which has been framed and focused on the appropriate area and hold the shutter open until a flash occurs. You can record a number of flashes for greater effect but if more than a few seconds elapse between flashes it is best to hold your hand over the lens while waiting. The pictures will look more interesting if you can include some foreground details such as roof-tops, chimneys, or trees to create a silhouette. The choice of aperture is a little difficult as it will depend on a number of variable factors; however, with a film of say ISO 100/21°, f8 and a bracket of one stop each side will be about right for average conditions.

■■■
Are there any special problems with underwater photography?

Yes, there are. The refractive effects of glass to water are different from those of glass to air, with the result that objects appear to be closer under water and your lens will have the effect of a longer focal length. To get the effect of a 50 mm lens, for instance, you would need to use a 35 mm lens. In addition, both the brightness level and the colour quality of light will be greatly affected as you go deeper and an underwater flash-gun is necessary for use below about 30 feet (10 metres); even at shallower depths you will need to use a fast film and a red colour correction filter in the order of 20–50 red to compensate for the absorption of the blue wavelengths of light when shooting in colour. You should also shoot when there is bright sunlight and in clear water, and avoid distant shots unless shooting towards the surface.

■■■
Is there any way of doing a panorama without joining the picture?

The inexpensive Kodak Stretch camera is now available or there are special panoramic cameras such as the Linhof Technorama which you can hire. Another way is simply to take consecutive pictures of a scene and mount or hang them together but not join them. Alternatively shoot a strip of film and make a contact print.

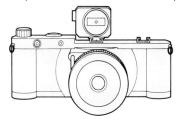

A Linhof Technorama camera.

What went wrong

■
Light has leaked on to one side of the film. What could have caused this?

The most likely cause is careless loading or unloading or leaving the film in bright light. Alternatively, it might be due to a badly fitting camera back. In the case of a roll film camera it can be caused by the film not winding tightly enough.

■■
Is flare more of a problem with some lenses than others?

Yes. As a general rule it tends to be more common with wide-aperture lenses, zooms, and long-focus lenses and less of a problem with wide-angle lenses.

This picture is an example of flare caused by the sun shining into the camera lens.

■■
What causes lens flare?

This is caused by bright light such as sunlight shining directly on to the lens where it is then reflected within the lens indiscriminately, allowing non-image-forming light to reach the film which causes fogging and a reduction in contrast and a pale image. In severe cases the shape of the iris diaphragm is actually visible.

■■
What causes over-development? This has happened although I gave the correct time.

It can also be caused by using the solution at too high a temperature, at the wrong dilution, or by excessive agitation.

■■
I have some pictures in which the corners are very dark as if something obscured the lens and yet this was not visible in the viewfinder of my SLR. What can have caused it?

This is almost certainly vignetting due to the use of a lens attachment which is too small for the field of view of the lens. It is often not noticeable when the image is viewed at full aperture but will show up when it is stopped down.

In this shot, the vignetted effect was caused by using a lens hood that was too small for the field of view of the lens.

■■■
What is reticulation?

It is a textured effect in the emulsion of the film caused by extremes of temperature during processing or by excess acidity or alkalinity, making the gelatin shrink and causing the emulsion to break up.

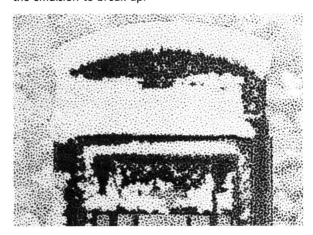

This reticulated negative is the result of high temperature during processing.

■■■
What is chemical fog?

It is a deposit of metallic silver which veils the unexposed and highlight areas of an image, and can be caused by stale developer or over-development.

■
I have taken some pictures on transparency film in which parts of the scene are very over-exposed although the rest of it is, if anything, rather dark. What went wrong?

This is because the brightness range of the subject was too great for the film to accommodate it and the exposure has resulted in the shadows being under-exposed and the highlights over-exposed on the same picture. The solution is either to frame the picture so that the extremes of brightness are excluded or to calculate the exposure so that either the shadows or the highlights are correctly exposed and simply to allow details at the opposite end of the scale to be lost.

The over-exposure in this picture is the result of the contrast of the subject being much too great for the film to record.
Nikon F3; 28 mm lens; 1/30 at f5.6; Kodachrome 25.

■
I took some still-life pictures indoors using flash and one edge of the pictures was badly under-exposed. Why did this happen?

This is almost certainly because you had the camera set on a faster shutter speed than the recommended flash setting, causing only part of the exposure to coincide with the flash. The under-exposed part of the picture was being recorded only by the ambient light.

■■
What are the various factors that cause unsharp pictures and how can I tell the difference between them?

Camera shake is the most common cause. This can usually be detected by the presence of a double image, and the whole of the image will also be affected. If there is a slight double image in only part of the image, but the rest is sharp, then the likely cause is subject movement with an insufficiently fast shutter speed to arrest it. If part of the image is sharp and other areas unsharp, but without any indication of a double image, the reason is probably inaccurate focusing or inadequate depth of field. If no part of the image is sharp, but there is no apparent double image, then either the image is totally out of focus (at a very close distance, for example), the lens is dirty or there was condensation inside it, or the lens is faulty or not properly aligned.

■■
Do filters affect flare?

Any additional glass or plastic surfaces will increase the problem of flare, especially if they are uncoated, as are the majority of filters.

■■
I often get under-exposed pictures. How can I find out the reason?

If an entire film or a series of pictures are under-exposed then there are a number of possible causes. You may have set the film speed dial to a higher number than that indicated for the film in use; with an automatic camera you may have inadvertently left the exposure compensation dial at a minus setting from a previous shot; or with a non-TTL camera you might not have made an allowance for a filter being used. If the fault is very consistent then there may well be a malfunction of the meter or possibly of the shutter. However, if only the occasional frame is under-exposed then it is much more likely to be because you did not make an allowance for abnormal lighting conditions such as shooting against the light or for a subject with an unusual tonal range, such as one containing large areas of light tone like a snowscape.

Nikon F3; 28 mm lens; 1/125 at f5.6; Ektachrome 64.

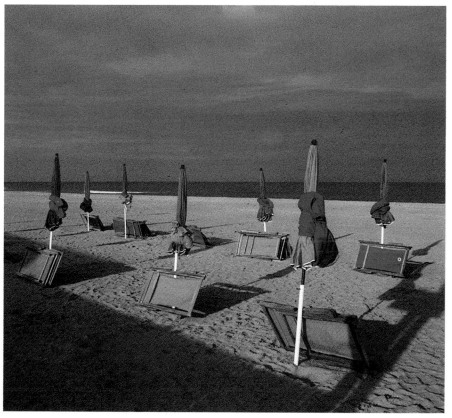

Useful information

■
Who invented photography?

Louis Daguerre made the first announcement of a method of fixing a photographic image on to a copper plate in Paris in 1839. This was known as the daguerreotype. Similar experiments were being pursued at the same time by an Englishman, William Henry Fox Talbot, and his quite different method was announced shortly after.

■■
I am interested in landscape photography and would like to study the work of some of the masters in this field. Can you suggest a few names?

Ansel Adams is a good example of the classical approach to black-and-white landscape, and perhaps John Blakemore for a more contemporary style. Ernst Haas and Franco Fontana have produced some stunning colour pictures of landscape subjects, as has the travel photographer Roloff Beny.

■■
Is it necessary to go to photographic college in order to pursue a career in photography?

A photographic college will give you a good background not only to photography but also to allied visual arts and will provide you with an opportunity to build up a portfolio and acquire a diploma. In some fields of photography this formal qualification would at least be an asset if not essential but by no means for all aspects of a photographic career. Many established photographers in fields such as reportage, fashion, and more creative work would generally argue that given a basic aptitude and a desire to take pictures the two or three years spent at college could be more usefully employed. This could be working as an assistant in a good studio, doing freelance work, and building up a portfolio in a less formalized way, as well as learning to work with the real pressures that exist in the commercial world.

■■
I would like to submit some of my work to magazines. How should I go about it?

First of all, you should be quite familiar with the magazines you intend to approach, with the type and style of picture they use and how they use them. If this is in line with your work then make sure that they do use freelance material, either by looking at the picture credits or simply by telephoning the picture editor to find out. If you decide to submit any work, put the transparencies in card mounts with protective plastic sleeves (never glass). Colour prints are rarely used. You should make good-quality black-and-white prints of about 8 × 10 in (20 × 25 cm) on a non-textured, preferably glossy, paper. Each picture should be captioned where appropriate and should be clearly marked with your name, address, and telephone number. Make sure that they are securely packed with adequate protection. It is a wise precaution to include return post and packing.

■■
I have been asked to take a passport photograph of someone. Are there any special requirements?

A passport photograph should measure 4.5 × 3.5 cm (approx. 1¾ × 1⅜ in), with the face length from the chin to the crown of head between 2.5 and 3.5 cm (1 to 1⅜ in).

■■
What are the copyright laws concerning amateur or semi-professional photographers who take commissions for events such as weddings?

In Great Britain, the copyright of a photograph belongs to the person who commissioned it unless another arrangement is specifically made. The negatives, however, belong to the photographer, again unless some other arrangement is made such as the client bearing the cost of the film and processing. In the United States, the photographer owns the copyright (even if he has been commissioned to take the photograph), unless it is assigned to another person in writing.

■■■
What is meant by reproduction rights when a picture is sold to a publisher?

In some cases when a picture is sold, to a magazine for instance, the fee paid is for a single use of the picture in one particular edition. When a picture is reproduced in a book, for example, the fee will be determined by a variety of factors: whether the book will be published in other languages or in a different form, or even if the picture is to be exclusive to that particular book. You should always make sure you know exactly what rights are required for each photograph you are selling since the difference between, for example, the fee for English-language rights only (excluding North America) and World rights can be considerable.

■■■
What is the best thing to do if I shoot a really dramatic news picture?

If you have shot a picture that is likely to be of national importance or interest, then the best course is to contact at once the picture desk of a national newspaper or possibly a news agency if you think that it has international relevance. Do not even wait until you have processed the photograph but get in touch with them straight away and follow their instructions.

■■■
I recently had some pictures ruined by a processing laboratory, and this had involved me in considerable expense. Do I have any redress?

No, I am afraid not. If you read the small print on either the film packet or the laboratory's terms and conditions you will almost certainly discover that liability is limited to the value of the materials.

■■■
Is it possible to remove stains when copying old black-and-white photographs?

Yes, it is often possible to remove them by shooting through a deep yellow or orange filter, but with a sepia tint this technique will not be effective as you will also lose detail in the light tones.

■■
What is a model release form and when is it needed?

This is a carefully worded agreement between a model and a photographer or publisher specifying the consent and terms under which photographs of a particular person can be published. Whenever pictures are taken of a recognizable person with the intention of publication it is advisable to ask the person to sign a model release form. The forms can be obtained from a number of organizations such as the Bureau of Freelance Photographers in Great Britain or the ASMP (Association of Magazine Photographers) in the United States.

These are two examples of photographs for which a model release form (right) would be required.
Top Pentax 6 × 7; 150 mm lens; f8 with studio flash; Ektachrome 64. **Bottom** Rolleiflex SLX; 150 mm lens; 1/250 at f8; Ektachrome 64.

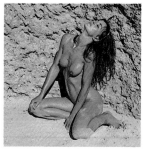

Model Release

Name of photographer

Number or description of photograph(s)

Date of photograph

For consideration received, I give ...* and all licensees and assignees the absolute right to copyright and use the photograph(s) described above and any other reproduction or adaptations thereof, in whole or in part, alone or in composite or altered form, or in conjunction with any wording or other photographs or drawings, for advertising, publicity, editorial or any other purpose.

I understand that I do not own the copyright in the photograph(s), and I waive any right to inspect or approve the finished use of the photograph(s).

I hereby release and discharge ...* and all licensees and assignees from any liability whatsoever, by reason of any distortion or alteration or use in composite or other form, whether intentional or not, which may occur in the making or use of the photograph(s).

I have read this release and am fully familiar with and understand its contents.

**I am over the age of majority and have the right to enter into this contract.
**I am not over the age of majority, but my parent/guardian agrees to these conditions.

Name

Signature Date

Address

Name of parent/guardian

Signature

Witness

Address
*insert photographer's name **delete as applicable

■■
I often like to take pictures at public events. Would it be worth my while buying a press pass?

Press passes of any value cannot be bought and are only issued by a newspaper or journal or by the organizers of the event to staff photographers or freelancers who have a definite market for their pictures. There are often only few suitable positions at such events and it is sometimes difficult even for national publications to obtain passes for their photographers. It is worth bearing in mind that the passes you might see advertised in photo magazines are totally worthless.

■■■
What information should be included in a caption to a picture which is submitted to a magazine?

It will depend to a degree on the nature of the picture but as a general rule the caption should say who or what the subject is, and why, when, and how it was shot. It is also advisable to include your own name and address within the caption, with a request for a picture credit. If the picture is being submitted to a photographic publication then technical details are often required, i.e. how the picture was taken, what type of camera, lens, and film were used, and even exposure details where appropriate.

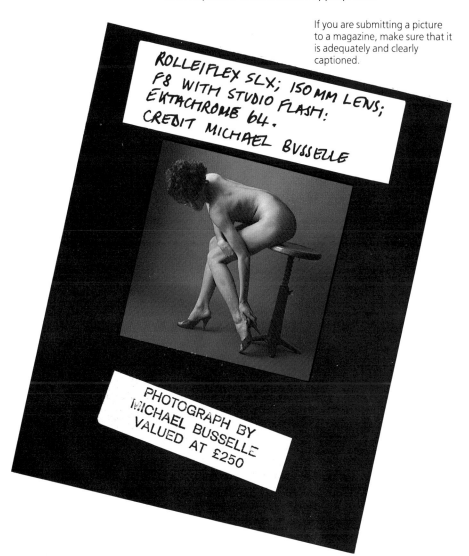

If you are submitting a picture to a magazine, make sure that it is adequately and clearly captioned.

ROLLEIFLEX SLX; 150 MM LENS;
F8 WITH STUDIO FLASH;
EKTACHROME 64.
CREDIT MICHAEL BUSSELLE

PHOTOGRAPH BY
MICHAEL BUSSELLE
VALUED AT £250

Practical photography

■■
Can colour prints be protected from fading caused by being displayed in bright light?

Some additional resistance to fading could be gained by spraying the print with a special solution designed to absorb ultra-violet light or by using coated picture glass.

■■
I would like to display some of my pictures on the walls of my home. What is the cheapest way?

There are two ways that are simple, inexpensive, and quite effective. One is to buy small metal spring clips which can be used to hold a print between a piece of picture glass and hardboard cut to the same size. Another is to use self-adhesive block mounts obtainable from art supply stores. These are panels of blockboard or thick foam polystyrene made in a range of sizes slightly smaller than the popular paper sizes, enabling the print to be pressed down and then trimmed flush.

Block mounts made of blockboard or foam polystyrene are available in a variety of sizes.

An unmounted print can be sandwiched between a piece of glass and a hardboard backing, fastened with metal clips.

■■
What is dry mounting?

It is a method of mounting a photograph or other material on to a supporting backing. A sheet of shellac or thermoplastic film is placed between the print and the mount and subjected to heat and pressure to create a bond.

■■
Is dry mounting the only satisfactory way to mount a photograph?

It is a method which produces a particularly flat and smooth finish, but other adhesives such as adhesive gum and aerosol spray mountant can be used quite successfully. It is important to ensure that they are recommended for photographic use as some domestic adhesives contain chemicals which can cause staining.

■■
What is the best type of album for displaying prints?

For small prints like enprints or instant pictures which form a family or holiday record, a good choice is one of the loose-leaf albums with an acetate overlay which protects the prints. This enables you to lay out a number of prints together attractively and also to rearrange them quite easily. Larger prints will usually look most effective when displayed singly; the most suitable type of album is a professional portfolio available from art supply stores.

■■
What, if any, damage will the X-ray equipment at airports do to films and cameras?

While this equipment will not harm cameras or processed film it can, however, in spite of notices to the contrary, fog unprocessed film. It is unlikely that any harm will be done by one scan from a low-dose machine (the ones that are supposed to be safe), but several scans can have a cumulative effect and can cause damage.

■■
What can I do to make sure that my film is not damaged by the X-ray equipment at airports?

If you have only a small quantity of film the best solution is probably to remove it from your camera bag and carry it on your person since the sonic device used for personal scanning will not harm it. Alternatively, if you have too much film to be able to do this you can ask for your luggage to be searched by hand. In this case it is best to pack your film separately in sealed cartons and to arrive in good time for your flight so that you can wait until the security people are not too busy and are less likely to refuse.

■■
Is it possible to buy lead-lined bags to protect film from the effects of X-ray equipment?

Yes it is, but they only offer a limited degree of protection and as they are likely to show up as an opaque shape on the scanner it will probably mean that your luggage will be searched by hand anyway.

■■
The X-ray machines at airports are supposed to be safe, so does that mean that I would not be able to claim if my film were damaged?

In practice it would be very difficult to prove that the X-ray machine was the cause of any damage and the compensation would almost certainly be restricted to the cost of the film. In most circumstances this would be small recompense for spoiled pictures.

■■
Are photographic libraries only interested in top-class prize-winning pictures?

No, on the contrary, as long as the technical quality is very high quite ordinary pictures are often in demand, such as an expanse of blue sea and sky for example, and fairly straightforward pictures of specific places, objects, and activities.

These four pictures are representative of the type of photographs in which photographic libraries are interested.

■■
How should colour transparencies be stored?

They should be stored in a cool, dry, dark place which is also clean and dust-free, and they should be kept in a protective sleeve or envelope of the type recommended for photographic use.

■■
I have discovered that some of my transparencies which have been stored for some years have developed what appears to be a fungus. How can I clean it off and how can it be prevented in the future?

This is not uncommon and is caused by an organism which actually attacks the emulsion. Consequently, the fungus cannot be cleaned off and the slides are unfortunately beyond repair. It is caused by poor storage conditions (primarily dampness and humidity). Correct storage should both prevent and arrest it but in a tropical climate, for example, you could use a special fungal preventative.

■■
What is the best way to store black-and-white negatives for maximum protection and permanence?

First of all, ensure that they are very well fixed and thoroughly washed, possibly with the use of a hypo clearing agent. Strips of negatives should be stored individually in protective sleeves or envelopes; the glassine type are not recommended for long-term storage, and the safest material is acid-free buffered paper. Ensure that no seams are in contact with the negatives and that they are not stored under pressure so that air can circulate. They should be kept in a clean, dry, cool, and dark atmosphere.

■■
Some of my glass-mounted transparencies have developed multi-coloured stains. What has caused this?

These are probably Newtons rings which are caused when two flat transparent surfaces are in partial contact. It can be prevented by the use of specially treated glass covers on the slides.

■■
Is it possible to remove a print from its mount after it has been dry mounted?

Yes, it is, but this must be done very carefully. Use a domestic iron which is set to a slightly higher temperature than that needed for mounting, cover the print with a protective layer of paper, and apply the iron gently to the surface of the print. Allow the heat just to melt the mounting tissue and at the same time carefully pull the print slowly away from the mount, starting from one corner.

■■■
Would it be worth my while to place some of my best pictures with a photographic library?

A photographic library can be an excellent way of earning fees from pictures you have taken, but most libraries will want to have a minimum number of transparencies, possibly several hundred or more, and you will have to agree to leave them in the library for a minimum period, often three years. Consequently, it is not an ideal use for pictures of which you are particularly fond unless the library will accept good-quality duplicate transparencies.

Bibliography

Complete Encyclopaedia of Photography, *Michael Langford*. Ebury Press.

The Handbook of Photographing People, *Michael Busselle*. Mitchell Beazley.

Wildlife and Nature Photography, *Michael Freeman*. Croom Helm.

The Darkroom Handbook, *Michael Langford*. Ebury Press.

Special Effects Photography, *Michael Langford*. Ebury Press.

Dialogue with Photography, *Paul Hill and Thomas Cooper*. Thames & Hudson.

On Photography, *Susan Sontag*. Penguin Books.

Photofinish, *Alex Morrison*. Michael Joseph.

Master Photography, *Michael Busselle*. Mitchell Beazley.

Cameras, *Brian Coe*. Marshall Cavendish.

Photodiscovery, *Bruce Bernard*. Thames & Hudson.

Nude and Glamour Photography, *Michael Busselle*. Macdonald.

World Photography, *Bryn Campbell*. Hamlyn.

Creative Camera Techniques, *Axel Bruck*. Focal Press.

Photography Pocket Guide, *Michael Busselle*. Octopus Books.

The Gentle Eye, *Jane Brown*. Thames & Hudson.

David Hockney Photographs. Petersburg Press.

Time Life Library of Photography. Time Life.

Henri Cartier Bresson Photographer. Thames & Hudson.

Darkroom Dynamics, *Jim Stone*. Newnes Technical Books.

Photographer's Handbook, *John Hedgecoe*. Ebury Press.

Advanced Photography, *John Hedgecoe*. Mitchell Beazley.

The Photographer's Weekend Book, *Michael Busselle*. Mitchell Beazley.

Monochrome Darkroom Practice, *Jack H. Coote*. Focal Press.

Professional Photography, *Michael Langford*. Focal Press.

Index

Numbers in italics refer to illustrations

Acknowledgements

All photographs in the book
were taken by Michael
Busselle, the author, with
the exception of the
following:
Chris White 103 (left), 131
(left), 176